BRISTOL
MOTOR
SPEEDWAY

BRISTOL MOTOR SPEEDWAY

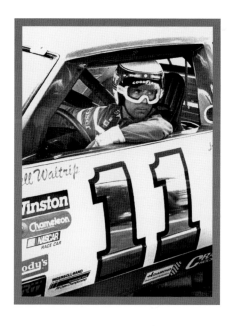

David M. McGee and Sonya A. Haskins

ARCADIA
PUBLISHING

For my family, who never failed to support a young man's fascination with motorsports,
and Mike O'Dell, whose remarkable love of racing was an inspiration.
—David M. McGee

For Ronnie Hawkins, Carol Nidiffer, Roy Gamble,
and all the other dedicated race fans in the world.
—Sonya A. Haskins

Published by Arcadia Publishing
Charleston, South Carolina

Printed in the United States of America

Library of Congress Catalog Card Number: 2005937662

For all general information contact Arcadia Publishing at:
Telephone 843-853-2070
Fax 843-853-0044
E-mail sales@arcadiapublishing.com
For customer service and orders:
Toll-Free 1-888-313-2665

Visit us on the Internet at www.arcadiapublishing.com

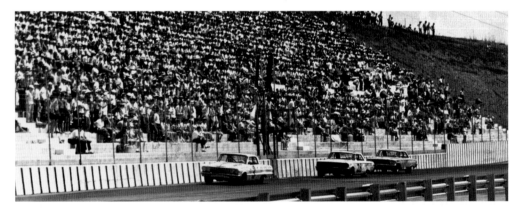

THREE RACING LEGENDS duel at Bristol. The Fords of Fred Lorenzen (28) and Glenn "Fireball" Roberts (22) overtake the Chevrolet of Junior Johnson (3) during the 1963 Southeastern 500. Roberts slipped past Lorenzen with seven laps remaining to take the win. Johnson raced to a third-place finish, three laps off the pace. (Courtesy of the Carl Moore collection.)

CONTENTS

FOREWORD BY RUSTY WALLACE

The great ones are known by one name, often two-syllable names, like Elvis. Maybe even, oh, I don't know, Rusty.

And then there's Bristol.

Bristol means a lot of great memories to me. Everybody knows I got my first win there and my 50th, but there's always something really special about that place. It's the most exciting track on the circuit and the night race there is just crazy with all those fans sitting right on top of the race track and the flashbulbs going off.

People have heard me say it's my favorite track, but Bristol's always been like a home track to me. I always ran great there and I love that area of the country. The fans are just great and I've got my car dealerships right down the road in Morristown, Newport, and Knoxville.

I still remember that first win. We didn't qualify all that great, but we kept working and working and I finally got around Darrell [Waltrip] and led, like, the last 100 laps. What a party we had that night.

I remember my 50th win because it took so doggone long to get. I won my 49th at Bristol in 1999 and I couldn't believe it took another whole year just to get that next win.

We won nine races and a ton of poles at Bristol, but we could have won so many more. We didn't just win. We always ran well, always had a chance to win. If I was down, just let me get back to Bristol to give me a lift. The track, the race, the fans . . . everything about the place lifts my spirits.

As high as I got over the years at Bristol, nothing matched the night of my last race. One of the coolest things that happened at Bristol was the tribute the track did for me in 2005. They gave me this sculpture for all my wins, and the fans in Turns 1 and 2 held up cards and spelled out my name. . . . Patti and I rode around the track in a convertible, and I'll tell you, of all the laps I've driven at that track, that was one of the most memorable.

It was really, really special. But that's Bristol.

Rusty Wallace ®

INTRODUCTION

There is only one Bristol Motor Speedway.

While much of modern-day stock car racing plays out on expansive tracks in metropolitan markets, Bristol offers a glimpse into the sport's past in a state-of-the-art setting. At Bristol, fans seated in any location can see all of the action, and the outcome is often decided by who has the sturdiest bumper and the strongest will.

In a business where promoters sometimes struggle to fill seats, Bristol's top-tier races remain sold out, just as they have for much of the past two decades.

In an industry where more and more tracks are built far from the sport's Southern roots, Bristol caters to fans with a slower pace off the track and a frenetic one on it.

Bristol's speedway is located in a narrow valley just off U.S. Highway 11E, a few miles from where Northeast Tennessee meets Southwest Virginia. Here, in this out-of-the-way place where the state line bisects the city's downtown, the massive racing complex offers a startling contrast to the fields, farms, and well-appointed homes that surround it.

Legendary drag racer John Force calls the track the "eighth wonder of the world," but unlike the crumbling Egyptian pyramids or the Colossus of Rhodes, the throngs who visit Bristol become part of the show. From performing a pre-race version of the wave around the oval to having their cheers and boos reverberate above the roar of unmuffled racing engines, Bristol offers the most intimate setting in motorsports.

In truth, there are probably only two kinds of race fans: those who attend races at Bristol Motor Speedway and those who want to.

Bristol is one of the world's largest sports stadiums, with seating for more than 160,000, but buying a ticket for one of those seats is nearly as challenging as driving to victory lane. Bristol may be the only venue in the world where the easiest way to get a ticket is to inherit one.

Twice each year, fans from every state and a dozen foreign countries make their pilgrimage to be part of the Bristol experience—equal parts rock concert and Roman Coliseum.

Modern high-rise aluminum grandstands and luxury suites completely encircle the racing surface. Yet the facility's heart remains the steeply banked half-mile of concrete where drivers race into the corners at nearly 140 miles per hour and experience G-forces greater than any roller coaster ride.

It is a place where tempers flare often and few escape an encounter with the concrete walls that surround it. Kyle Petty and Mark Martin compare racing at Bristol to flying jet fighters in a gymnasium.

Fans simply say that nowhere else compares to Bristol, which could explain why they historically select Bristol as their favorite NASCAR track and its August night race as their favorite event.

Part of the mystique is the unforgettable moments that have unfolded there, from the late Dale Earnhardt's epic cage-rattling tangles with Terry Labonte, to Rusty Wallace's first win and his 50th. There have been remarkable winning streaks by Darrell Waltrip, Cale Yarborough, Jeff Gordon, and Kurt Busch, and the unforgettable day Michael Waltrip walked away from one of the most devastating crashes in racing history.

The track's current incarnation bears little resemblance to the facility that Larry Carrier, Carl Moore, and R. G. Pope began building in 1960.

When the gates opened for the first time in the summer of 1961, fans sat on concrete grandstands carved into two hillsides along the half-mile oval's front and back straightaways. In those days, tickets were readily available for $3, $4, and $5, and Moore admits many were given away to help fill the 18,000 seats.

Over the past four decades, the speedway has changed ownership five times, and each owner has written his own chapter in its best-selling success story.

Founders Carrier and Moore established the facility and, much like proud parents, nurtured it through its infancy. Nashville businessmen Gary Baker and Lanny Hester bought it in 1977 and moved the August race from Sunday afternoon to Saturday night a year later. The change offered a throwback to racing's roots and some respite from summer's sweltering heat, and sparked a new level of fan interest. California industrialist Warner Hodgdon became Bristol's next owner in 1983, as he acquired a number of speedways. Hodgdon supported expansion plans and brought Larry Carrier back to manage the facility. It was during their tenure that Carrier convinced then-fledgling cable television network ESPN to deliver the night race to a live television audience.

Within two years, however, Bristol appeared on the brink of extinction. Hodgdon declared bankruptcy, and a local bank took the track into receivership. Unlike Bristol, another Hodgdon-owned track in Nashville, Tennessee, lost both its Winston Cup races during that time.

After Hodgdon's bankruptcy, the bank selected Carrier to oversee the track's operation, and he worked with NASCAR to assure racing continued. Carrier was able to buy the track a year later, and Bristol soon found new favor amid unparalleled growth in the sport. During the next 10 years, the track's seating capacity tripled to about 70,000 as the demand for tickets grew.

Once considered just another short-track stop on the NASCAR circuit, Bristol's rising popularity attracted the interest of Bruton Smith's Speedway Motorsports, who paid more than $25 million for the facility in January 1996.

In the decade since, Smith's organization literally moved mountains to provide parking and roadways and meet other needs of a steadily increasing influx of fans.

Smith calls Bristol a "phenomenon."

Even that is an understatement.

THROUGH THE DECADES

You can basically see everything around this track. The design of the track makes it so unique. The noise it creates, the thunder, the excitement and as fast as you're running a half-mile and all those people. . . . All of those things are definitely what make it that exciting.

—Rusty Wallace

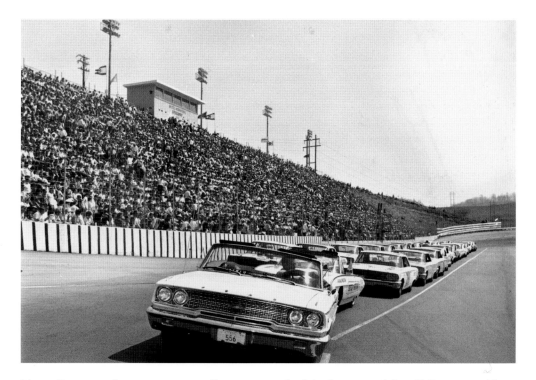

THE BRISTOL INTERNATIONAL SPEEDWAY grandstands are full of anxious race fans as the field for the 1963 Southeastern 500 assembles behind the pace car. The half-mile Bristol oval was the only newly built track on the 52-race schedule during its debut 1961 season. Along with numerous other changes through the decades, the track's name has changed several times. (Courtesy of Bristol Motor Speedway [BMS] archives.)

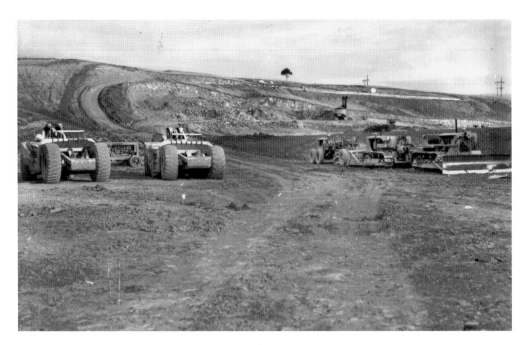

SHOWN HERE ARE TWO of the earliest construction photographs of the speedway, taken February 11, 1961. Crews had just begun carving out the hillside and pouring concrete for the top row of frontstretch grandstands but still hadn't begun forming the oval-shaped track. (Photographs by John Beach.)

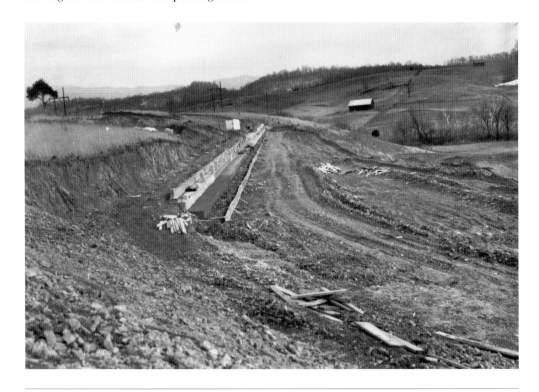

THROUGH THE DECADES

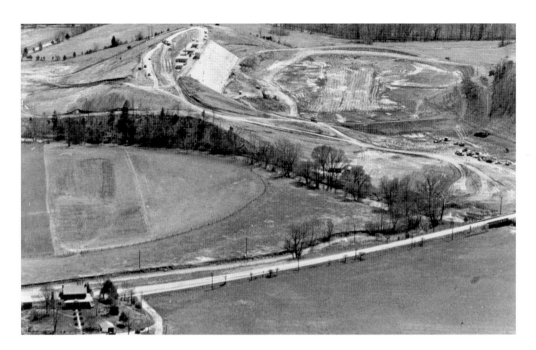

IN THE TOP VIEW, from 1961, the original frontstretch grandstands and basic layout of the oval that will become known as the World's Fastest Half Mile have begun to take shape. U.S. Highway 11E is in the foreground. Below, looking across the four-lane 11E in a more recent photograph, all of the property within a mile of the track is filled as 160,000 jam into the expanded, renowned facility. (Both images courtesy of BMS archives; bottom photograph by Donna Price.)

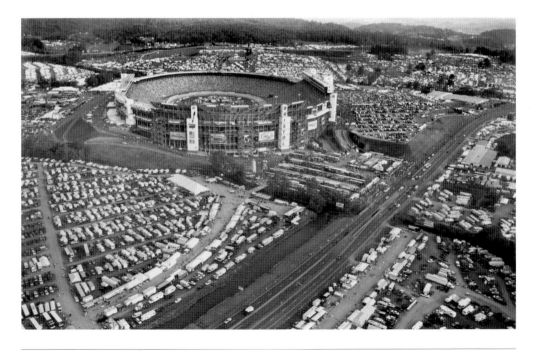

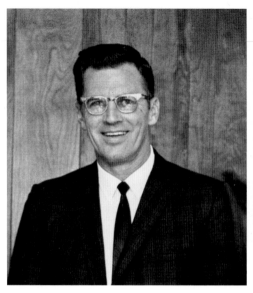

SPEEDWAY FOUNDERS LARRY CARRIER (left) and Carl Moore (right) were motorsports pioneers, establishing both an oval track and world-class dragway in Bristol during the 1960s. (Courtesy of the Carl Moore collection.)

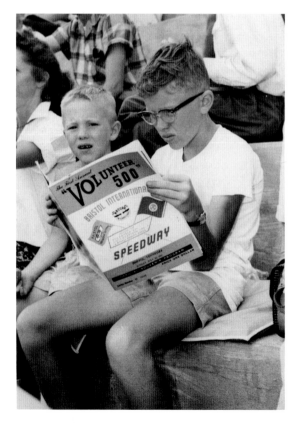

THIS YOUNG FAN CHECKS OUT the souvenir program for the 1961 Volunteer 500. Bristol's first race for the former NASCAR Grand National division was run on July 30. (Courtesy of the Carl Moore collection.)

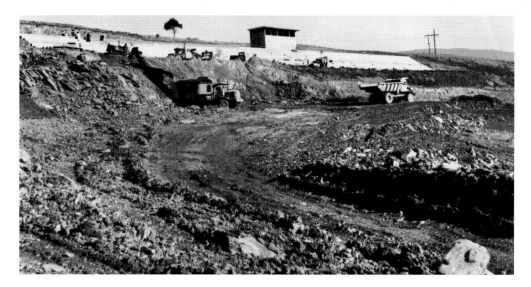

CONCRETE GRANDSTANDS AND THE FRAMEWORK of the original control tower have begun to take shape in this photograph from March 2, 1961. Crews have also begun moving dirt to form the foundation for the original half-mile racing surface, which featured 22-degree banked corners when it opened for the 1961 season. The 36-degree banking was not added until July 1969. (Photograph by John Beach.)

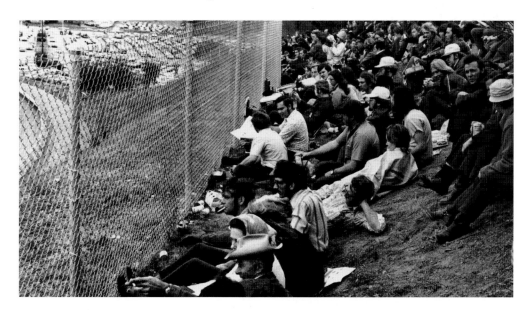

DECADES BEFORE HIGH-RISE GRANDSTANDS and suites, the hillsides around the track offered a great view of all the racing action. Fans in this photograph from the early 1960s are already developing a unique personality of their own, dedicated to their favorite drivers and willing to show up in various sorts of weather—even without a seat in this case. (Courtesy of BMS archives.)

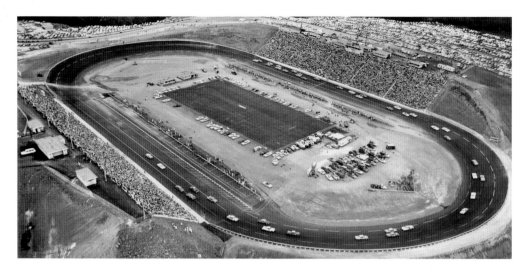

ALL 42 CARS RACE around the brand-new Bristol International Speedway during its first race, the July 30, 1961, Volunteer 500. A capacity crowd turned out to watch Jack Smith win with relief help from Johnny Allen. Located in the center of the track is a football field where the Washington Redskins and Philadelphia Eagles later played an NFL exhibition game. (Courtesy of Bill McKee; photograph by Harrison Hall.)

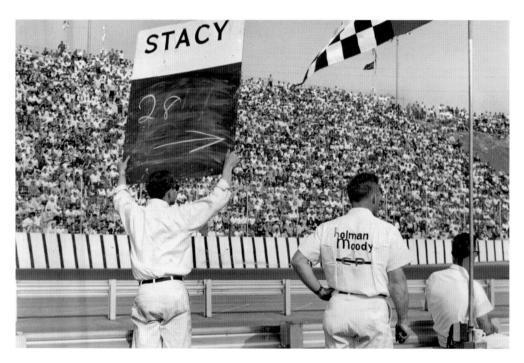

IN THE DAYS BEFORE RADIO communication, teams used hand-held blackboards to communicate important information to their drivers. Here a crewman hopes to get Nelson Stacy's attention during the early 1960s. (Courtesy of BMS archives.)

THROUGH THE DECADES

THIS IS THE COVER of the program for Bristol's second major race, the 1961 NASCAR Southeastern 500, run on October 22, 1961. Promoters later switched the dates of the races, so the Southeastern became the spring race and the Volunteer became the summer event.

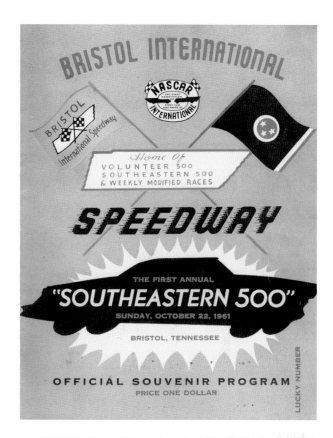

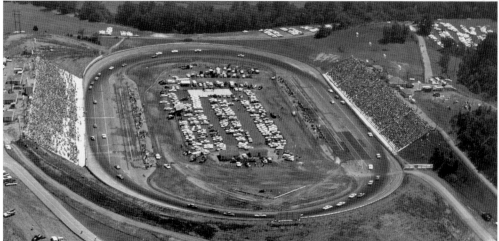

AN AERIAL VIEW OF BRISTOL International Speedway during the 1963 season shows the relatively flat 22-degree banking in the corners and a number of empty seats along the front-stretch grandstands. Early Bristol races tested both man and machine: half the field was typically not running at the finish because of accidents or mechanical failures. (Courtesy of the Carl Moore collection.)

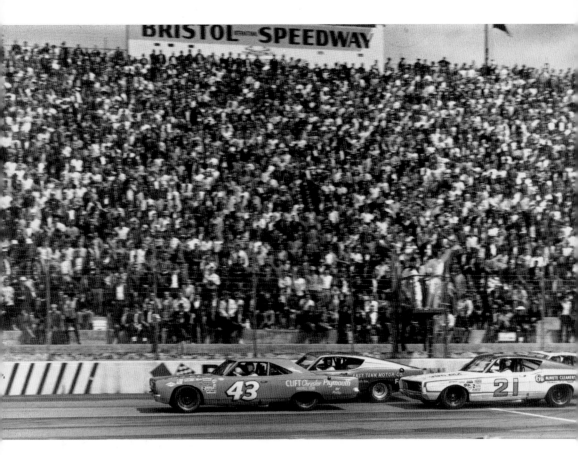

RICHARD PETTY (43) LEADS David Pearson (17) and Cale Yarborough (21) across the start/finish line during the 1968 Southeastern 500. After the trio traded the lead 10 times during the first half of the race, Pearson went on to score one of two Bristol wins and that season's championship. Prior to 1969, when the banking was increased, cars qualified at an average speed of 88 miles per hour. At the first race after the change, the pole speed immediately jumped to more than 103 miles per hour, eventually setting the stage for Bristol's claim as the World's Fastest Half Mile track. (Photograph by John Beach.)

THROUGH THE DECADES

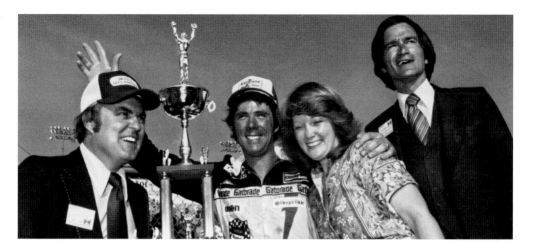

FORMER BRISTOL OWNERS LANNY HESTER (left) and Gary Baker (right) flank Darrell Waltrip (center with wife, Stevie) after the 1978 Southeastern 500, the first of 12 Waltrip wins. Hester and Baker bought the facility from Larry Carrier and Carl Moore before the 1977 season. Baker bought Hester out in 1980. Baker and Hester are best known for moving the August race from Sunday afternoon to Saturday night, igniting a new wave of interest. (Courtesy of BMS archives.)

SHIFTING THE SUMMER RACE to Saturday nights brought the fans back to Bristol. Racing under the lights makes the cars appear to go faster and makes it easier to see when sparks fly. Action like three-wide racing between Cale Yarborough (11), Joe Millikan (43)—who substituted for Richard Petty—and Cecil Gordon (24) provides its own set of thrills. (Courtesy of BMS archives; photograph by David Allio.)

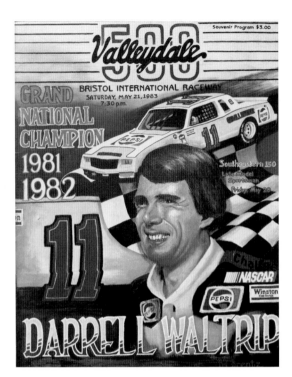

THE PROGRAM FOR THE 1983 Valleydale 500 celebrated the Bristol accomplishments of Darrell Waltrip. Artist Bonnie Brentz provided the painting used for the cover.

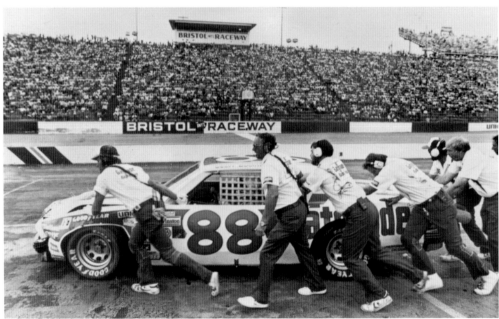

CREW MEMBERS FOR GEOFF BODINE (88) push the Gatorade Pontiac off pit road during the 1983 Valleydale 500, the last race for owner Gary Baker. Warner Hodgdon, who bought a 50-percent interest in the track in 1982, bought the remaining 50 percent in July 1983 and hired former owner Larry Carrier to serve as general manager. (Courtesy of BMS archives.)

THROUGH THE DECADES

DURING THE 1980S, PACKED GRANDSTANDS became the norm at Bristol, as the track and NASCAR racing continued to gain popularity. Here members of the Morgan-McClure team attend to their Oldsmobile. Valleydale, a meat-packing company that operated in Bristol, became the track's first title sponsor to have its name on the spring race from 1980 to 1991. It is not unusual for race names to change at the sponsor's request, and the name for this race changed twice. (Photograph by John Beach.)

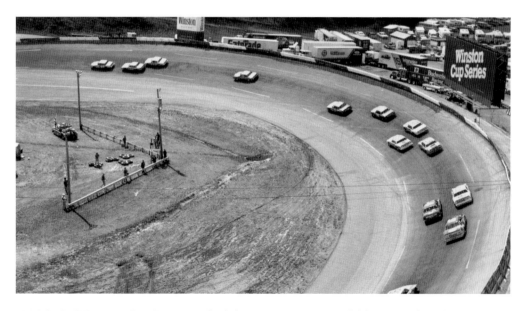

NASCAR WINSTON CUP TEAMS parked their 18-wheel transporters outside the track and rented smaller vehicles to service cars in the pits prior to the late 1990s. This view from the 1984 Valleydale 500 reveals how much infield space was available. Note that about a dozen photographers are standing behind single sections of guardrail to capture the action. (Photograph by Mike O'Dell.)

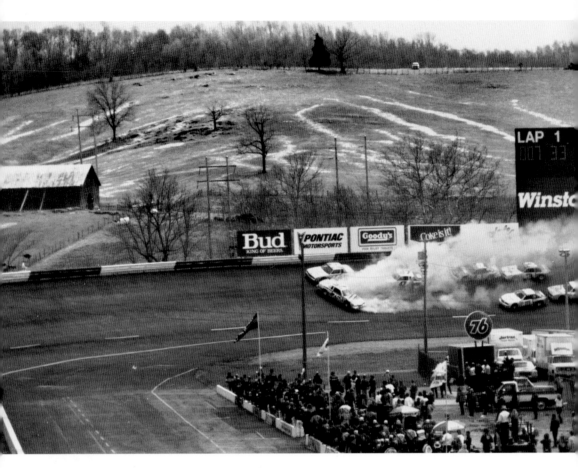

THERE WERE NO GRANDSTANDS above Turn 4 in 1985 when Lake Speed (75) spun in front of the field during the Valleydale 500. With limited demand for camping, the rolling hillside behind Turns 3 and 4 was still farmland. The track was in receivership at that time, after former owner Warner Hodgdon declared bankruptcy. (Photograph by David McGee.)

THROUGH THE DECADES

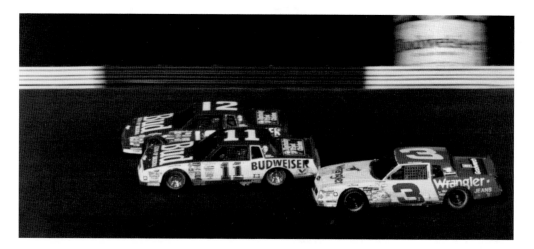

DALE EARNHARDT (3) LOOKS to the inside of Darrell Waltrip (11) and Neil Bonnett (12) during the 1985 Busch 500. All three took turns leading a race slowed by 11 cautions. Earnhardt outran Tim Richmond for the win, while Bonnett and Waltrip finished third and fourth respectively. It marked the first night the race broadcast live on ESPN. (Courtesy of BMS archives.)

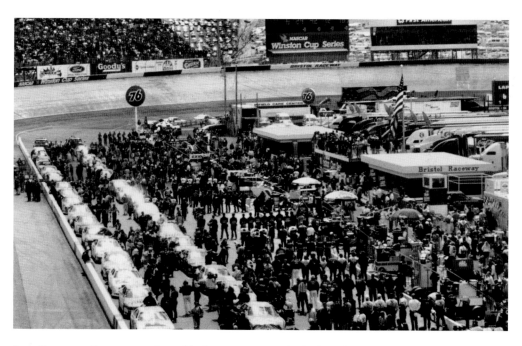

IN A PRE-RACE RITUAL conducted before every NASCAR race, crews line up along pit road and stand silently for the pre-race invocation and national anthem. In a sport where people put their lives on the line every time they go to work, faith and prayer are much more than just an afterthought; they are a way of life for many of the competitors. Pre-race programs at BMS often have a patriotic theme. (Photograph by David McGee.)

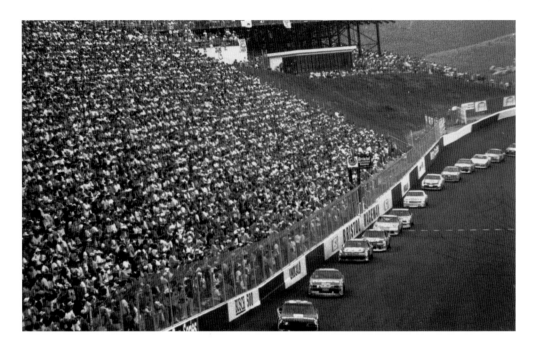

THE TRACK UNDERWENT A MAJOR grandstand expansion prior to the 1990 season. Here a sellout crowd of about 45,000 watches as Dale Earnhardt and Mark Martin lead the field for that August's Busch 500. (Photograph by David McGee.)

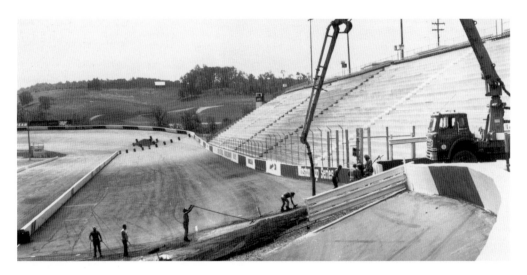

WORKERS ATTEMPT TO PATCH the asphalt surface at the exit of Turn 2 prior to the August 1991 race. After numerous attempts to resurface, reseal, and repair it, former speedway owner Larry Carrier ripped out the asphalt after the 1992 Food City 500. Despite being told concrete would never work, Carrier and local concrete company owner Joe Loven installed the current racing surface in time for the August 1992 Bud 500. (Photograph by John Beach.)

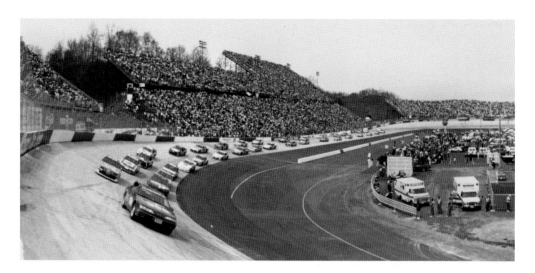

NEW SECTIONS OF GRANDSTANDS were installed along the backstretch and turns during the 1990s, as the demand for Bristol tickets continued to grow. Here the pace car leads the field for the 1993 Food City 500.

In its September issue for that year, *Stock Car Racing* magazine provided an in-depth look at Bristol, calling it "Racing's Toughest Track" in a cover headline. (Photograph by David McGee.)

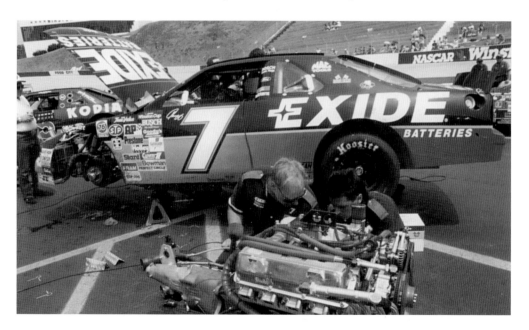

UNTIL RECENT YEARS, NASCAR teams typically prepared one engine for qualifying and another for the race at every track on the circuit. Here crew members for Geoff Bodine prepare to install the race engine into his Exide

Batteries–sponsored Ford prior to the 1994 Food City 500. Bodine purchased the team of the late Alan Kulwicki in 1993 and drove his own cars through the 1998 season before selling out. (Photograph by David McGee.)

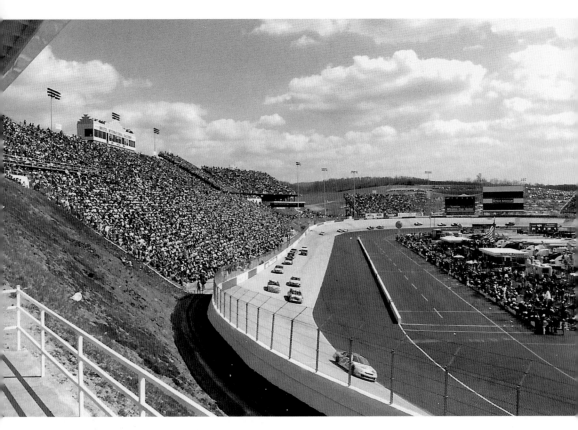

SEATING CAPACITY WAS ABOUT 70,000 when the 1995 Food City 500 took the green flag under perfect weather conditions. A new second tier of grandstands and a larger control tower dominated the skyline along the front stretch, back toward Turn 4. Smaller stands and a new suite building were constructed in Turn 3. (Photograph by David McGee.)

THROUGH THE DECADES

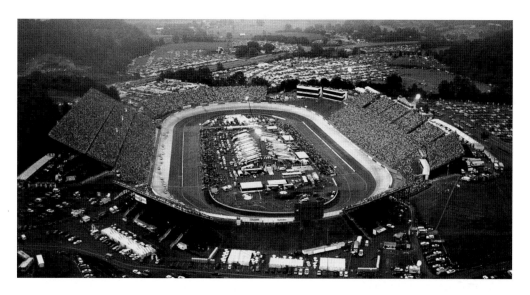

IN 1995, OWNER LARRY CARRIER oversaw a series of grandstand expansions at the track, at the time known as Bristol International Raceway, that increased seating capacity to about 70,000. Carrier talked about expanding to 100,000 but wound up selling the facility the following year. (Courtesy of BMS archives; photograph by Donna Price)

ARTIST GARY HILL CONTRIBUTED this version of the 1995 Goody's 500 finish, with Dale Earnhardt spinning Terry Labonte, as cover art for the 1996 night race souvenir program.

BRUTON SMITH (LEFT) ANSWERS a question during the January 22, 1996, news conference at which the Charlotte businessman announced he had purchased the Bristol track. Co-founder Larry Carrier (right) sold the facility for $25.5 million. (Photograph by David McGee.)

SINCE THE PURCHASE, Bristol Motor Speedway has been proof of owner Bruton Smith's favorite axiom that the "road to success is always under construction." Smith has invested more than $160 million in the complex with expanded seating, suites, access routes, restrooms, concessions, elevators, and other fan amenities. (Photograph by David McGee.)

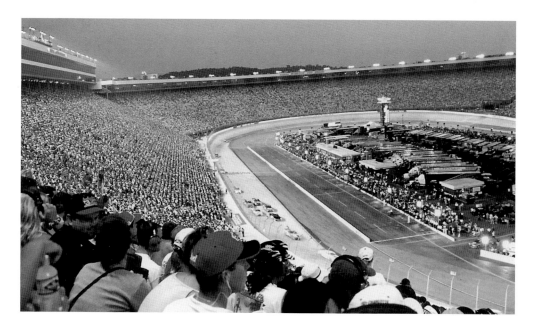

BY AUGUST 1999, SEATING capacity had risen to 131,000, with fans completely encircling the half-mile oval. An infield scoring pylon, which displayed the top 10 positions and a rolling menu of the rest of the field, had also been added. Fans who used to sit on the hillside overlooking Turn 1 and see a herd of cattle off Turn 4 now saw only a sea of humanity. (Photograph by David McGee.)

ONE OF THE BIGGEST CHANGES under Bruton Smith's reign had nothing to do with seating or parking but competitor convenience. Here work crews install a tunnel beneath Turn 3 to allow drivers, crews, sponsors, and media much easier access to the pits and garage area. Prior to this, when cars were on the track, people had to wait until the action stopped and NASCAR opened a gate to allow access. (Photograph by Mark Marquette.)

THE TREND OF SELLOUTS that began in the 1980s has continued into the 21st century. Fans from all 50 states and a dozen foreign countries congregate at Bristol Motor Speedway twice each year for top NASCAR events. With 160,000 people jammed onto about 100 acres during these races, the Bristol speedway becomes one of the most densely populated sites on earth. Farm fields in every direction are covered by cars and campers. More than 200 suites now ring most of the facility's upper deck, and Bristol has more elevators than any single building in Tennessee. (Top photograph by Carol Hill; bottom photograph courtesy of BMS archives; photograph by Donna Price.)

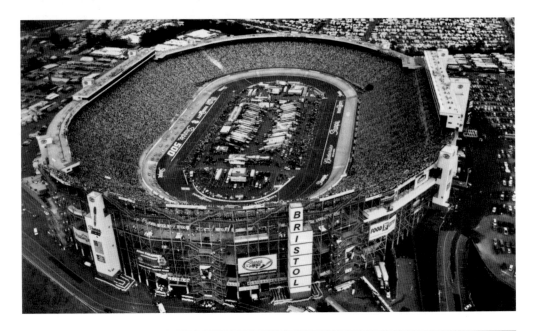

THROUGH THE DECADES

DRIVERS

LOCALS TO LEGENDS

*It's just incredible. And I know it makes the hair stand up on my arms on Sunday afternoon
when we come out here and they say, "Gentlemen start your engines," and the crowd goes crazy.
It's probably one of the best places to go racing.*

—Steve Park

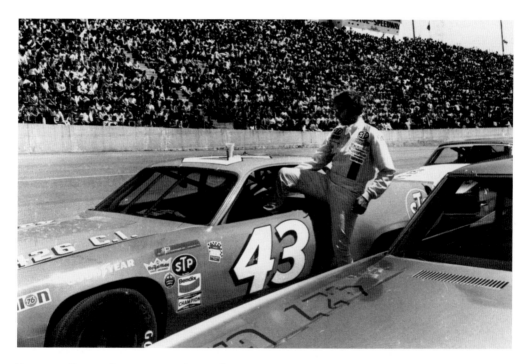

RICHARD PETTY CLIMBS INTO the cockpit of his No. 43 Plymouth prior to the start of the 1972 Southeastern 500. The packed house saw Bobby Allison dominate the race, Bobby Isaac finish second, and Petty third. Petty went on to defeat Allison for that season's Winston Cup title, the first season the schedule was reduced from nearly 50 races to 31. R. J. Reynolds, the new series sponsor, insisted on the change for marketing reasons. (Photograph by John Beach.)

BROTHERS DUB (LEFT) AND SHERMAN Utsman, from nearby Bluff City, Tennessee, were among three Utsman family members who competed in Bristol's first race, the 1961 Volunteer 500. Sherman finished 9th after starting 20th, while Dub wound up 29th in the 42-car field. Uncle Layman finished last in his only Bristol race. (Courtesy of BMS archives.)

JOHN A. UTSMAN IS the only local racer to be part of winning a Cup series race at Bristol. Driving in relief of Benny Parsons, the Bluff City, Tennessee, native helped steer the L. G. DeWitt–owned Chevrolet to victory in the 1973 Volunteer 500. Parsons got out of the car on lap 251 and Utsman drove for 170 laps. Parsons got back in to finish the race, as the tandem won by seven laps over L. D. Ottinger. (Courtesy of BMS archives.)

DRIVERS: LOCALS TO LEGENDS

JACK SMITH WON BRISTOL'S premier
event, the Volunteer 500, on July 30,
1961, with relief help from Johnny Allen.
Under NASCAR rules, the driver who
starts the race receives credit for the
finish, regardless of who is driving when
the checkered flag falls. Smith got out
because the hot floorboard burned his
foot and Allen drove the final 209 laps.
Only half of the 42-car field finished the
race. (Courtesy of BMS archives.)

BOBBY JOHNS ESTABLISHED A new track
qualifying record during the 1961
Southeastern 500 with an average speed
of 80.64 miles per hour. His No. 47
Pontiac was owned by Jack Smith,
winner of Bristol's first-ever race. Johns
led the first 30 laps but finished a poor
17th in the 38-car field. (Courtesy of
BMS archives.)

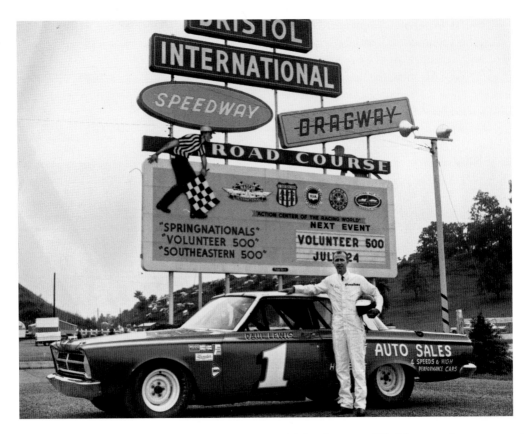

PAUL LEWIS OF JOHNSON CITY, Tennessee, poses with his No. 1 Dodge in front of the speedway sign prior to the 1965 Southeastern 500. Lewis made seven Bristol starts and posted two top-five finishes, including a second-place run in the 1966 Southeastern 500. The sign also promotes the Bristol Dragway, which opened in 1965, and an ill-fated USAC (United States Auto Club)–sanctioned road course formerly located on the property. (Courtesy of BMS archives.)

BILL MORTON (1) TRAILS ENGINE SMOKE from his Chevrolet as Glenn "Fireball" Roberts (22) passes on the high side during the 1963 Southeastern 500. Morton, from nearby Church Hill, Tennessee, won the track's weekly Modified racing title in 1961 and competed in NASCAR's top division during the 1950s and early 1960s. Roberts, one of the sport's legends, won that race in his first start for car owners John Holman and Ralph Moody. Roberts died the following year after a racing accident. (Courtesy of BMS archives.)

DRIVERS: LOCALS TO LEGENDS

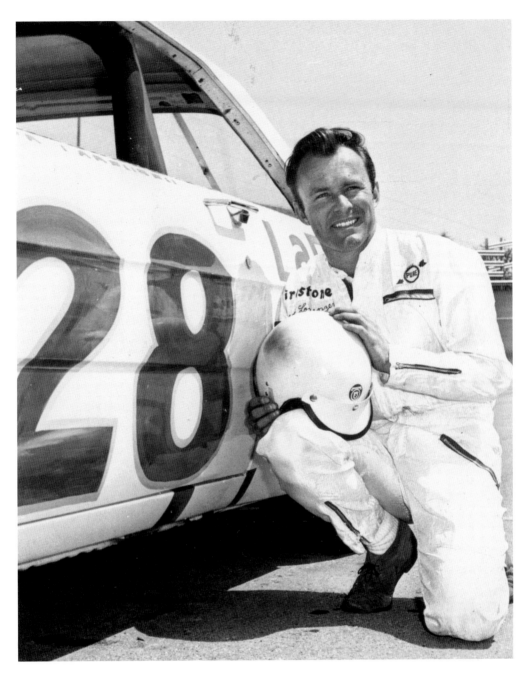

FRED LORENZEN WAS THE FIRST driver to dominate Bristol. He won the pole for two of the track's first three races but blew the engine both times while leading. He came back in 1963 to sweep both poles and finish second and first in those races. Lorenzen was the first driver to win two and three straight races there and the first to win both races in a single season. (Courtesy of BMS archives.)

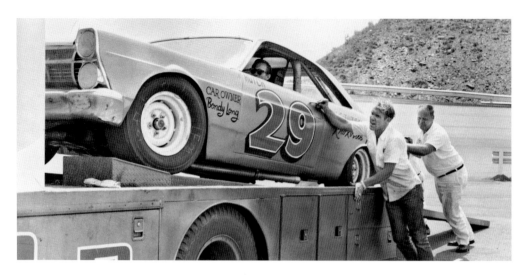

CREW MEMBERS LOAD DICK HUTCHERSON'S Ford, owned by Bondy Long, onto the truck after blowing an engine during practice for the 1967 Volunteer 500. After changing the engine, Hutcherson bounced back to finish second behind Richard Petty. Hutcherson, an Iowa native, earned one Bristol win, in 1965, and posted five top-five finishes in his five Bristol starts. (Courtesy of BMS archives.)

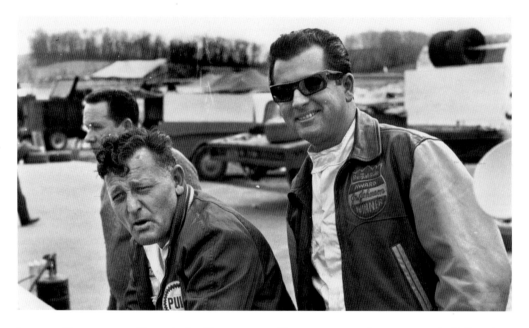

LEEROY YARBROUGH (RIGHT) IS PICTURED with crew chief Herb Nab prior to the 1968 Southeastern 500. One of the sport's biggest stars of the 1960s, Yarbrough had six top-five finishes in 13 Bristol starts. His best Bristol effort came in the spring of 1969, when he finished second behind Bobby Allison. The team was owned by Junior Johnson. (Photograph by John Beach.)

Donnie Allison (Second from Left) and Richard Petty (in sunglasses) are among the folks in line during a 1970s cookout at Bristol. (Courtesy of BMS archives.)

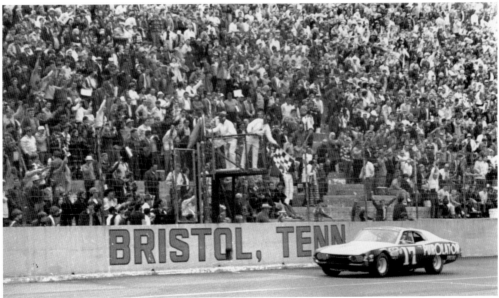

David Pearson Flashes Beneath the checkered flag before a packed house of 25,000 to win the 1971 Southeastern 500. Pearson's victory was the 60th of his career, his last at Bristol, and the last there for car owners Holman and Moody. Richard Petty rallied to finish second after losing a wheel and a lap during the final 100 laps of the race. (Photograph by John Beach.)

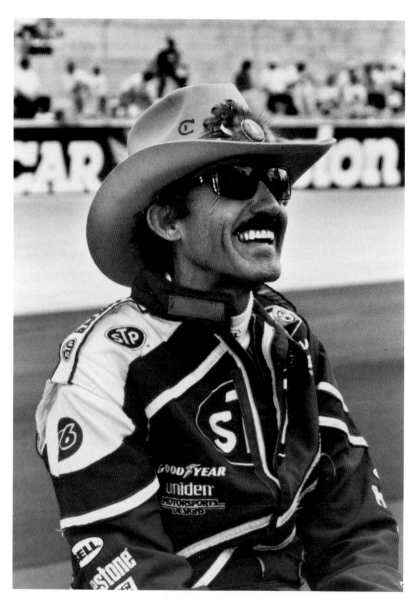

KNOWN AS THE "KING" of stock car racing, seven-time Cup series champion Richard Petty had only modest success at Bristol. He competed in the track's first-ever race in 1961 and finished with 62 career starts, 3 victories, 26 top-5 finishes, and 37 top-10 finishes. Since most of those races were in the era before big payouts, his Bristol career winnings totaled just $300,000. Here Petty flashes his trademark smile prior to qualifying during his final season behind the wheel of his No. 43. Petty had reason to smile that day, April 2, 1992, when he qualified 14th in the 32-car field for the Food City 500. However, his fortunes would take a downward turn on race day, as mechanical problems relegated Petty to a 27th-place finish. Petty's last Bristol start was later that summer, August 29, 1992. (Photograph by David McGee.)

DRIVERS: LOCALS TO LEGENDS

LEE PETTY (RIGHT) TALKS with his son Richard during the 1967 Southeastern 500. Richard won an amazing 13 races that year, but a lap six crash put him out of the spring race. He came back in July to sit on the pole and collect the first of three Bristol wins during the Volunteer 500. (Courtesy of the Carl Moore collection.)

COMING OR GOING, the silhouette of Richard Petty is unmistakable. After retiring from the driver's seat in 1992, team owner Petty was relegated to a seat in the team's pit area the following season. Only three of Petty's 200 wins came at Bristol, where the seven-time series champion recorded 10 second-place finishes. (Photograph by David McGee.)

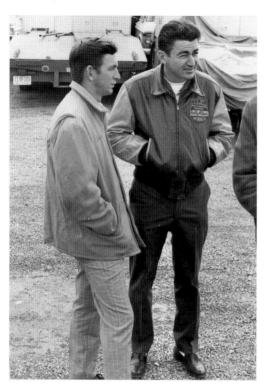

BROTHERS BOBBY (RIGHT) AND DONNIE Allison are the only siblings to win in NASCAR's top division in the Cup series at Bristol. The brothers swept 1970, when Donnie edged out Bobby for the spring race and Bobby won the July race. Older brother Bobby also won at Bristol in 1969 and twice in 1972. They are among six sets of siblings who have competed in the Cup division at Bristol through 2005. (Courtesy of BMS archives; photograph by John Beach.)

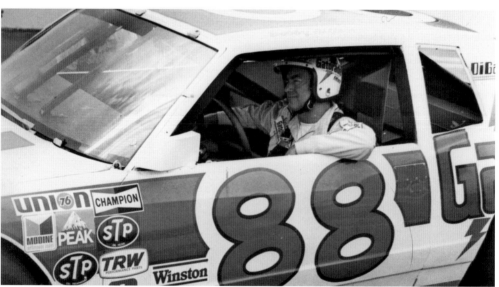

BOBBY ALLISON MADE THE MOST of his single season driving for the No. 88 Gatorade team, winning eight races and battling Darrell Waltrip for the 1982 Winston Cup title. Allison posted two top-five finishes at Bristol and dominated the August race before losing the lead to Waltrip with 20 laps remaining. Allison left Bristol with a 65-point advantage, but Waltrip won five of the year's last seven races to take the title. (Photograph by Mike O'Dell.)

DRIVERS: LOCALS TO LEGENDS

DRIVER DAVEY ALLISON (LEFT) talks with Jimmy Makar. Allison became the first of three sons of NASCAR Cup Series winners to follow their fathers to Bristol's victory lane. Allison won in 1990, after his father, Bobby, scored four wins in the 1960s and 1970s. Since that time, both Dale Jarrett and Dale Earnhardt Jr. have followed Ned Jarrett and Dale Earnhardt, respectively, with Bristol wins. Davey's 1990 win was also the first at Bristol to come from a pit stall along the track's backstretch. (Photograph by David McGee.)

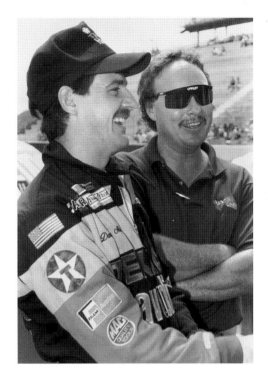

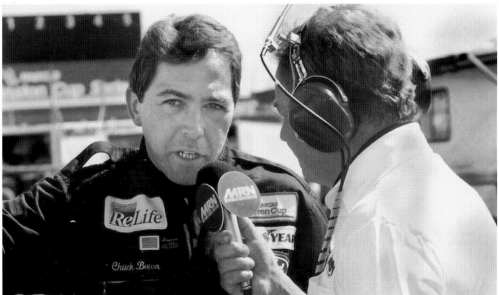

FORMER BUSCH SERIES CHAMPION Chuck Bown (left) does a radio interview with Barney Hall of Motor Racing Network after winning the pole for the 1994 Food City 500 in a Ford owned by Bobby Allison. Bown's racing luck turned sour and, after being involved in an accident, he finished 23rd. Hall is the dean of race announcers and previously served as the track's public address announcer. (Photograph by David McGee.)

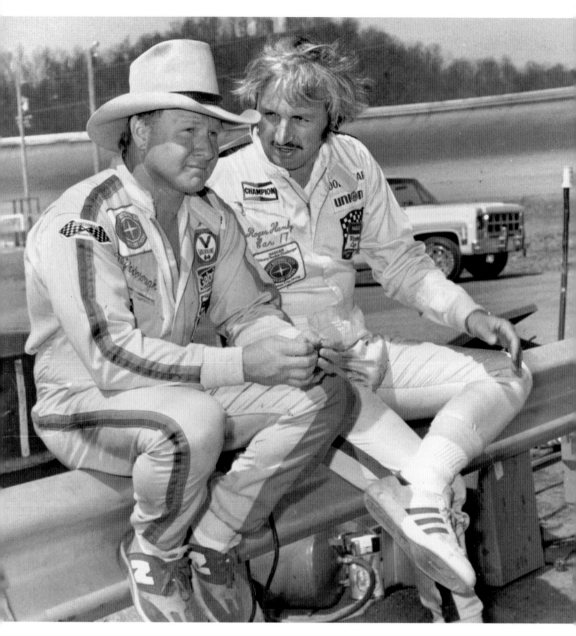

ROGER HAMBY (RIGHT) APPEARS to be asking Cale Yarborough about the fastest way around Bristol's 36-degree-banked corners. Hamby posted a 17th-place finish in his first Bristol start in April 1978. That race proved to be the only one Yarborough failed to win during a six-race period from 1976 to 1978. Yarborough finished his career with nine Bristol wins, leading more than 3,400 laps. (Courtesy of BMS archives.)

DRIVERS: LOCALS TO LEGENDS

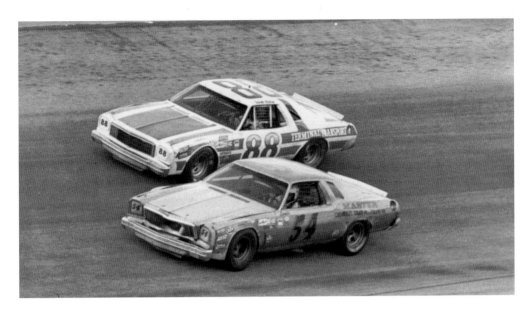

DARRELL WALTRIP (88) TRIES TO PASS Lennie Pond (54) on the outside as they battle for second place in the 1975 Volunteer 500. Pond, who beat Waltrip for 1973 Rookie of the Year honors, finished second behind Richard Petty that day, while Waltrip raced to third place in only his third Bristol start. (Courtesy of BMS archives.)

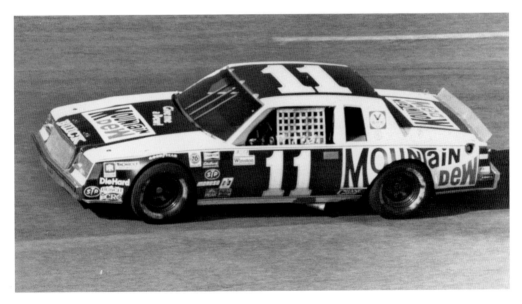

IN FOUR BRISTOL STARTS with the Mountain Dew sponsorship colors on his Junior Johnson Buicks, Darrell Waltrip won all four races, three pole positions, reset the track qualifying record once, and led more than 800 of the 2,000 laps contested. The team's dominating seven-race winning streak began in 1981, when this photograph was taken. (Photograph by Mike O'Dell.)

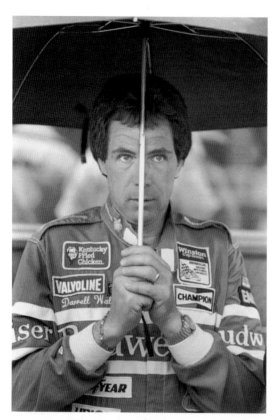

BRISTOL DOMINATOR DARRELL WALTRIP strikes a silly pose while waiting out a rain delay prior to the 1985 Valleydale 500. After starting ninth, Waltrip's Chevrolet fell out because of engine failure after only 178 laps. (Courtesy of *Bristol Herald Courier*; photograph by Bill McKee.)

HOMETOWN RACER BRAD TEAGUE is among a handful of drivers who have competed in all three of NASCAR's top divisions—Cup, Busch, and Truck—at Bristol. A native of nearby Johnson City, Tennessee, Teague made his first Bristol Motor Speedway Winston Cup start in March 1982, finishing 12th. He was a standout in the former NASCAR Sportsman division and earned one career Busch Series win at Martinsville Speedway in Virginia. (Photograph by David McGee.)

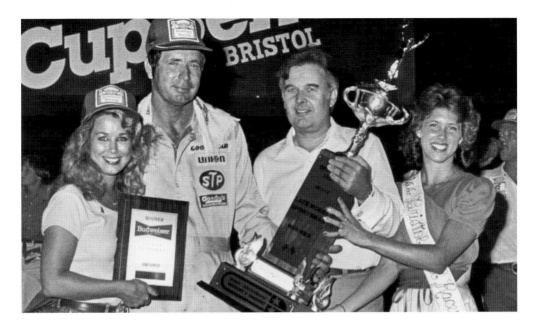

FORMER TRACK OWNER WARNER HODGDON (second from right) presents the winner's trophy to Sam Ard after he captured the Free Service 150 in August 1983. Ard notched 10 victories and 10 poles that year to capture the first of his two NASCAR Busch Series championships in the division's second season. (Photograph by David McGee.)

WITH THE EXCEPTION OF HIS lone short-track win during his 1988 NASCAR championship season, Bill Elliott never enjoyed great success at Bristol. Shown here during a test prior to the spring 1992 race, Elliott drove the Junior Johnson–owned Ford to a 20th-place finish, 30 laps behind race winner Alan Kulwicki. That would later prove pivotal in their race for the season championship, as Kulwicki edged Elliott by a scant 10 points. (Photograph by David McGee.)

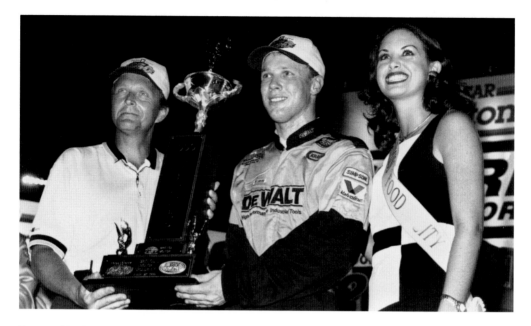

BEFORE HE BECAME THE FINAL Winston Cup champion, Matt Kenseth was a star in the NASCAR Busch Series. He finished second in that series in 1998 and third in 1999 while earning his first Bristol Busch Series win in the 1999 Food City 250. Here Tom Hembree presents Kenseth the trophy. Kenseth led the final 93 laps, holding off Michael Waltrip and Dale Earnhardt Jr. for the win. (Photograph by Carol Hill.)

VETERAN RICKY RUDD WAS SHUT out of Bristol's victory lane in the 56 Cup series starts he made between 1975 and 2005. Rudd, a Virginia native, qualified on the pole in 1984 and finished second four times. During one stretch from 1989 through 1992, Rudd scored eight consecutive top-10 finishes at Bristol. (Photograph by David McGee.)

DRIVERS: LOCALS TO LEGENDS

NOT ONLY DID RUSTY WALLACE collect a lot of race wins at the World's Fastest Half Mile, he earned seven Bud Pole awards, which signify being the fastest qualifier. His 1997 pole for the Food City 500 snapped a four-race stranglehold by Mark Martin. Wallace was heading toward an apparent win when Jeff Gordon tapped Wallace on the final lap and slipped past him to take the victory. (Photograph by David McGee.)

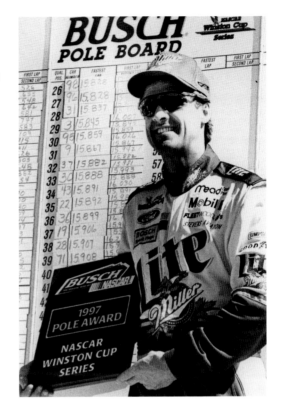

"TEXAS" TERRY LABONTE HAS HAD PLENTY to smile about at Bristol. The two-time Winston Cup champion used his first career win at Bristol's August night race as a springboard to the 1984 season championship. His second Bristol win is easily the most memorable, as he took the 1995 checkered flag backwards after a tap by second-place Dale Earnhardt. (Photograph by David McGee.)

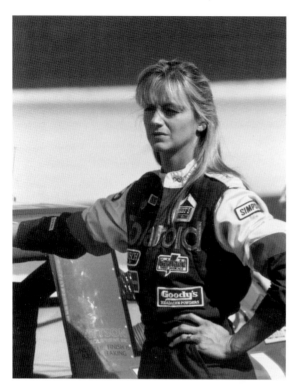

SHAWNA ROBINSON PREPARES TO CLIMB into her No. 35 Polaroid Pontiac Busch Series entry owned by Mike Laughlin. Robinson is one of three female drivers to have competed at Bristol in the Busch Series, and she posted a career-best 11th place finish at Bristol in 1993. Robinson also raced Goody's Dash cars and diesel trucks at BMS. Through 2005, only one female, Janet Guthrie, has raced in the Cup division at BMS. (Photograph by David McGee.)

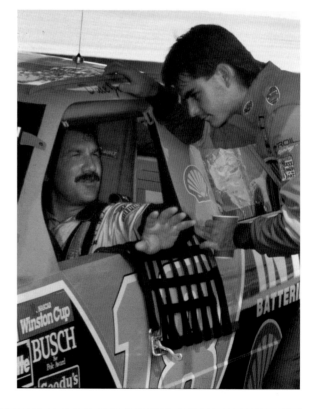

DALE JARRETT (LEFT) TALKS with Jeff Gordon during practice for the 1994 Food City 500. Jarrett, the son of two-time NASCAR champion and former broadcaster Ned Jarrett, became the second driver to follow his father into Bristol's victory lane. The elder Jarrett's lone Bristol win came in the 1965 Volunteer 500. After several name changes, the Volunteer 500 eventually became the Goody's 500, which Dale Jarrett won in 1997. (Photograph by David McGee.)

MARK MARTIN RELAXES WITH an ice-cream bar while sitting on the deck lid of his Jack Roush–owned Folger's Coffee Ford in 1990. Locked in a furious season-long points battle with Dale Earnhardt, Martin qualified second and finished third in the Bristol's August race to extend his margin to 61 points. It wouldn't prove enough, however, as Earnhardt battled back late in the season to edge out Martin by 26 points. (Photograph by David McGee.)

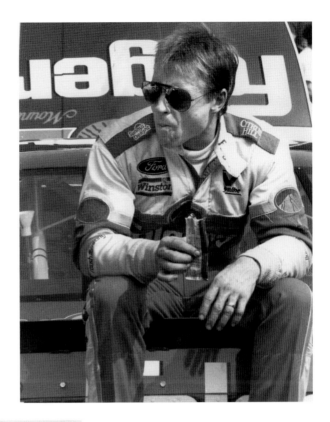

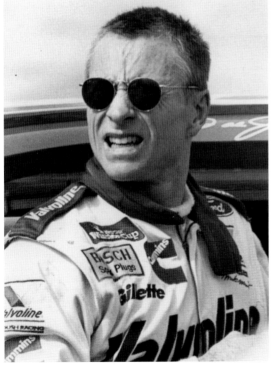

MARK MARTIN SAID BRISTOL reminded him of some of the high-banked short tracks where he learned to race. He certainly found the fastest way around the oval, earning seven career poles and two wins. Martin etched his name in the track's record book when he won the pole for four straight Cup races in 1995 and 1996, the only driver to accomplish that feat to date. (Photograph by David McGee.)

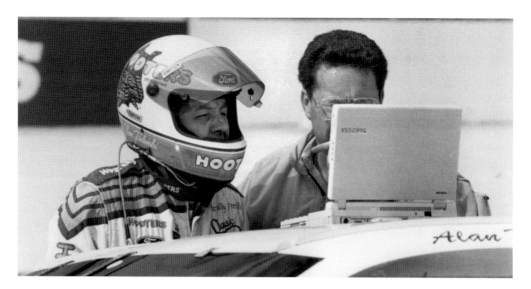

FROM DRIVING TO CAR PREPARATION, 1992 NASCAR champion Alan Kulwicki (left) was a perfectionist. Here Kulwicki reviews his car's performance on a laptop computer during a March 1993 Bristol test session. He never got to use the information—he was killed in a plane crash two weeks later. The Wisconsin native won twice, had three poles, and recorded 8 top-10 finishes in 14 Bristol starts. His independent team unveiled its Hooters Restaurants sponsorship at Bristol in 1991 and carried those colors to both wins. (Photograph by David McGee.)

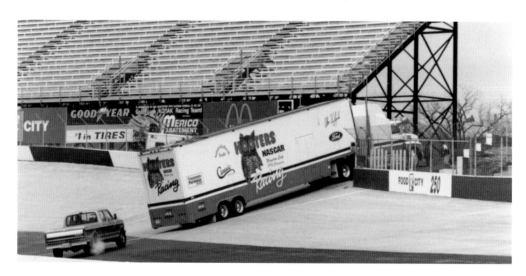

ONE OF THE SADDEST SIGHTS in Bristol's long history occurred on Friday morning, April 2, 1993, when Alan Kulwicki's transporter left the pit area, just hours after a plane crash took the life of the 1992 Winston Cup champion. Kulwicki and three others died the previous night when his private plane slammed into a field near Blountville, Tennessee, just miles from Tri-Cities Regional Airport. (Photograph by David McGee.)

DALE EARNHARDT SMILES
BROADLY after winning the
1988 Busch 500. He celebrates
the win with wife, Teresa (left),
and a former Miss Winston.
Just to the right, a 13-year-old
Dale Earnhardt Jr. waits to join
in the festivity. In 2004, it was
Earnhardt Jr. who smiled for the
cameras after his first Bristol win.
(Photograph by John Beach.)

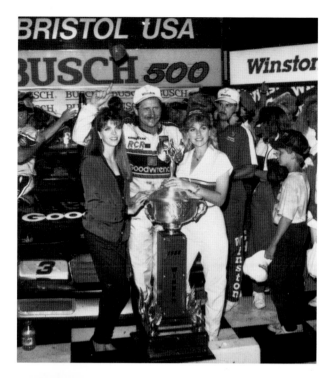

DALE EARNHARDT JR. (8) LEADS his
famous father (3) through Turn 4 at
Bristol during the 2000 Goracing.com
500. After winning two Busch Series
championships in 1998 and 1999,
Earnhardt Jr. advanced to the Winston
Cup Series and was second in the
rookie-of-the-year competition. Four
years and two days later, he became the
first driver to sweep Busch and Cup
series wins at Bristol Motor Speedway.
(Photograph by David McGee.)

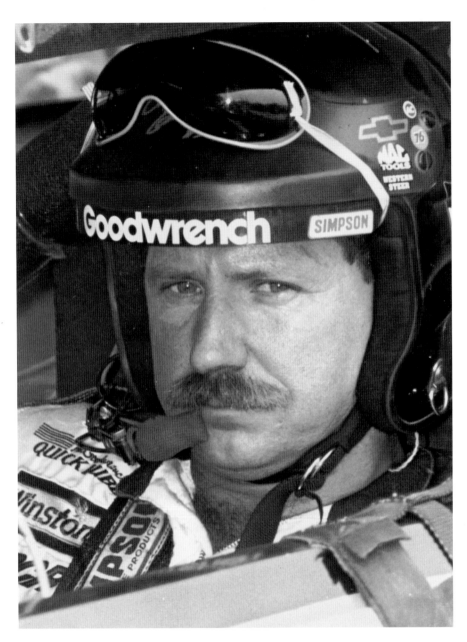

FROM THE FIRST TIME he saw the 36-degree banked turns and short straightaways of Bristol, Dale Earnhardt was a force to be reckoned with. He won the 1979 Southeastern 500, beating established stars Bobby Allison and Darrell Waltrip in his first-ever Bristol start. With a reorganized team, Earnhardt came back a year later to repeat the victory, with Waltrip and Allison in tow. In 43 Bristol starts, Earnhardt posted 9 wins, 20 top-5 and 30 top-10 finishes, 2 poles, and more than $1.8 million in winnings. Of the track's most prolific winners, only Cale Yarborough and Darrell Waltrip had a better winning percentage. The "Intimidator's" last BMS win came in 1999. (Photograph by David McGee.)

DRIVERS: LOCALS TO LEGENDS

DALE EARNHARDT COLLECTS his first career Winston Cup victory at the Southeastern 500 on April 1, 1979, in only his 16th series start. Earnhardt led 164 laps to outrun Bobby Allison and Darrell Waltrip, the only other drivers on the lead lap. The No. 2 team was owned by Rod Osterlund and overseen by crew chief "Suitcase Jake" Elder. (Courtesy of BMS archives.)

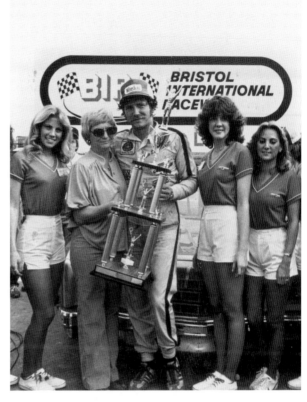

THOUSANDS OF SHOCKED RACE FANS came from several states to gather at BMS two days after Dale Earnhardt was killed in a racing crash at Daytona in 2001. They brought souvenirs, roses, and their emotions to a somber service in the track's pit area. Most made their way to the same victory lane where Earnhardt made nine visits. (Photograph by David McGee.)

DEWAYNE "TINY" LUND LOOKED MORE like a football player than race car driver when he climbed out of Bud Moore's NASCAR Grand American Series Cougar during a 1968 Bristol tire test. The series, which ran from 1968 to 1972, featured cars like the Cougar, Chevy Camaro, and Ford Mustang. Lund was the 1968 series champion and posted 41 career victories in the Grand American Series. Donnie Allison won in the series' only Bristol appearance in 1968. (Photograph by John Beach.)

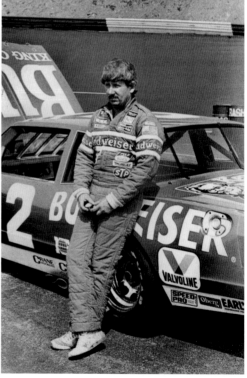

NEIL BONNETT USES A STOPWATCH to keep tabs on the competition while taking a break from practicing his No. 12 Chevrolet. While Bonnett never made it to victory lane, he was often a factor at Bristol. During the 1985 season, when this photograph was taken, the Alabama native qualified third and fourth in the two races and posted a strong third-place finish in the August Busch 500. (Photograph by Mike O'Dell.)

NON-STOP ACTION

I remember years ago I was coming off Turn 2 and the spotter said there was a wreck
in Turn 4. You can't get stopped by the time you get there. You can't just jam the brakes on.
Somebody is going to run over you.

—Dave Marcis

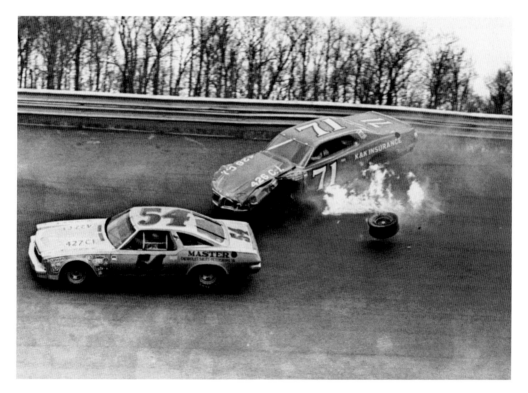

FLAMES EMERGE FROM BENEATH the K&K Insurance Dodge after driver Buddy Baker lost a left front tire on lap 225 of the 1973 Southeastern 500. Baker was uninjured, but the car was too badly damaged to race on. Lennie Pond (54) narrowly avoided the single-car incident and held on for a sixth-place effort in his first Bristol start. (Courtesy of BMS archives.)

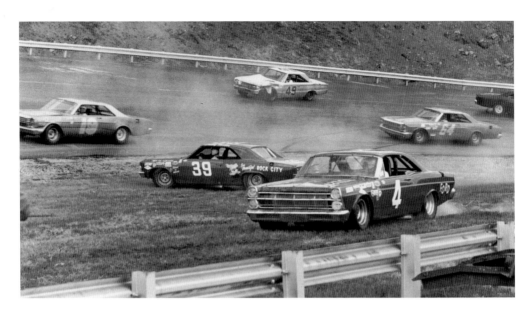

JOHN SEARS (4) DRIVES ONTO the infield grass to avoid a multi-car crash during the running of the 1968 Southeastern 500. Friday Hassler's Chevrolet (39) sits sideways on the apron, and G. C. Spencer (49) was also involved. Henley Gray (19) and Elmo Langley (64) were able to avoid the crash, and Langley emerged with a ninth-place finish. (Photograph by John Beach.)

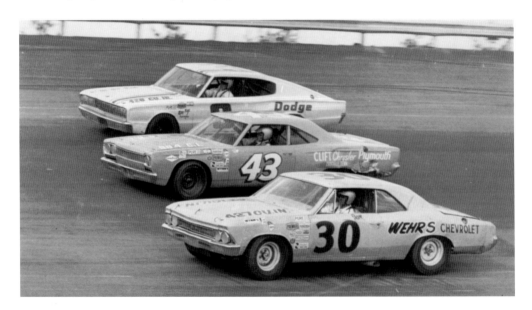

DRIVERS DAVE MARCIS (30), Richard Petty (43), and Buddy Baker (3) race three-wide during the early going of the 1968 Southeastern 500. Baker dropped out with overheating problems before the race's mid-point, but Petty went on to finish second behind David Pearson's Ford. Marcis finished 13th in his first Bristol start. (Photograph by John Beach.)

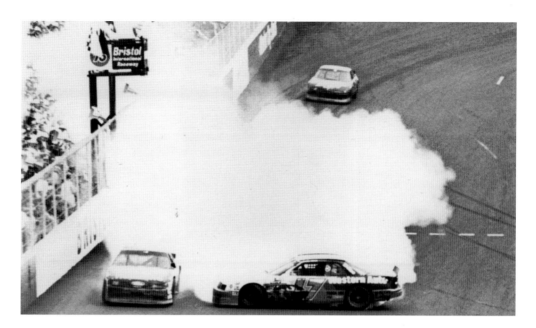

SMOKE FROM DARRELL WALTRIP'S spinning tires completely obscures the start/finish line during the 1991 Valleydale Meats 500. The lap 368 spin occurred after contact from Davey Allison's Ford and brought out the 15th of 19 caution periods. Allison was penalized and sent to the rear of the field, and Waltrip recovered to finish sixth. Mark Martin (left) finished fourth. (Photograph by David McGee.)

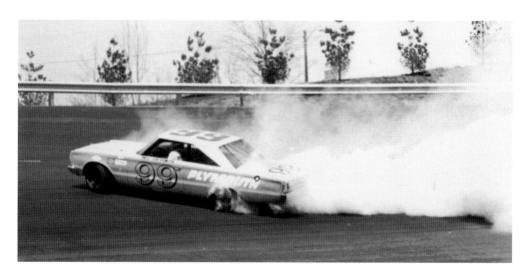

PAUL GOLDSMITH (99) GOES for a ride in Turn 1 during the 1966 Southeastern 500. Goldsmith, who won the previous week's race in Rockingham, North Carolina, started third at Bristol. Distributor problems forced Goldsmith to park his Ray Nichels–owned Plymouth after 256 laps. He came back in July to win the Volunteer 500. (Courtesy of the Carl Moore collection.)

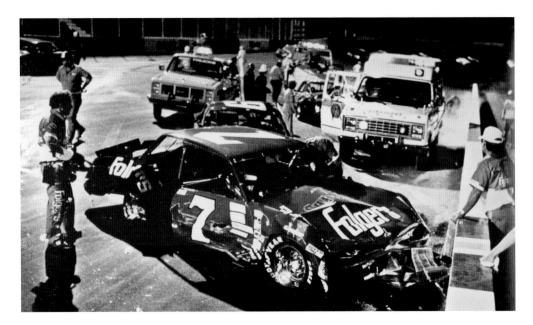

CREW MEMBERS AND SAFETY WORKERS look over the damage of the Ed Whitaker–owned Busch Series Pontiac after a grinding multi-car crash along the front stretch during the 1985 Tri-City Pontiac 200. Driver Joe Ruttman was uninjured. (Photograph by Earl Neikirk.)

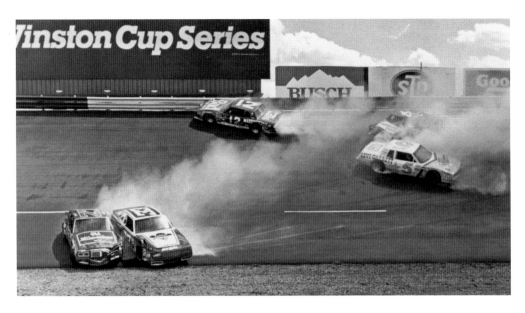

FIVE CARS WERE INVOLVED in this lap 36 crash during the 1985 Valleydale 500. The machines of Tim Richmond (27) and Joe Ruttman (4) were too badly damaged to continue. Geoff Bodine (5), Neil Bonnett (12), and Harry Gant (33) were able to make repairs, and all three were running at the finish, winding up 18th, 19th, and 20th, respectively. (Courtesy of BMS archives.)

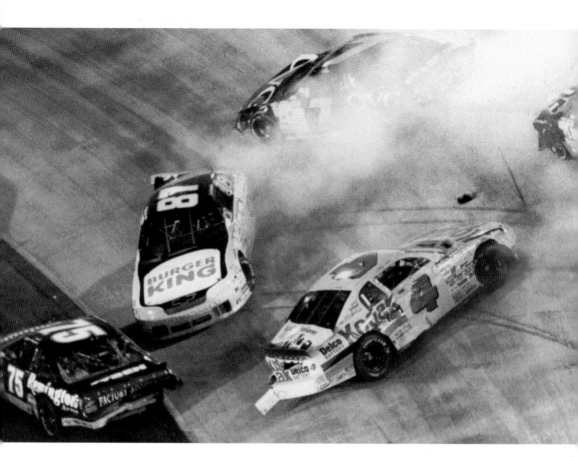

JOE NEMECHEK (87) AND STERLING MARLIN (4) spin between Turns 1 and 2 as part of a multi-car accident during the 1996 Goody's 500. Morgan Shepherd (75) avoids Nemechek's car by diving onto the asphalt apron, but Geoff Bodine (7), Jeff Burton (99), and Ken Schrader (25) aren't so fortunate. (Photograph by David McGee.)

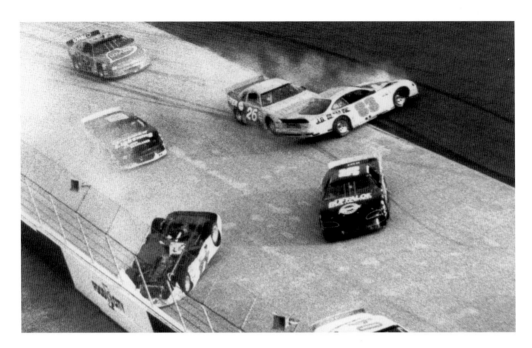

DRIVERS SCATTER IN EVERY DIRECTION as one car winds up on its top during the 1996 All-Pro Series race at Bristol. The All-Pro cars competed several times at BMS and offered some of the wildest racing action. The cars were so quick, NASCAR mandated they run restrictor plates under the carburetors to reduce horsepower and slow their speeds. (Photograph by David McGee.)

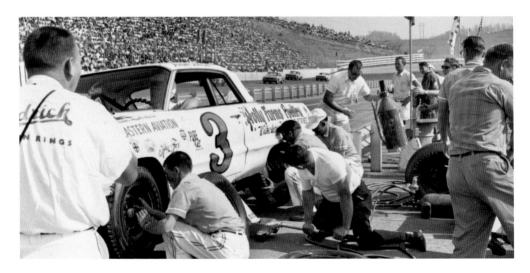

CREW MEMBERS PUT LEFT-SIDE tires on driver Junior Johnson's No. 3 Chevrolet during the 1963 Southeastern 500, the first year promoters switched names of the two races. Johnson qualified fourth fastest and finished third behind the Fords of Fireball Roberts and Fred Lorenzen. (Courtesy of BMS archives.)

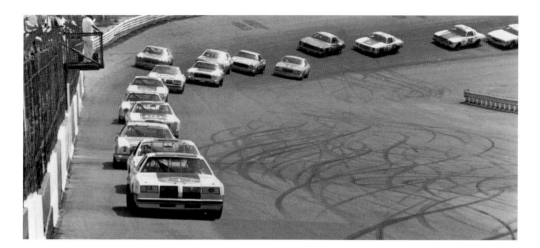

WHILE THE CARS ARE NEATLY single-file here, the graffiti of tire marks on the asphalt speak volumes about the perils of Bristol. Cale Yarborough leads the pack past the start/finish line during the 1978 Southeastern 500. He did not keep the lead on this day, however, as Darrell Waltrip interrupted Yarborough's winning streak to take the checkered flag. (Courtesy of BMS archives.)

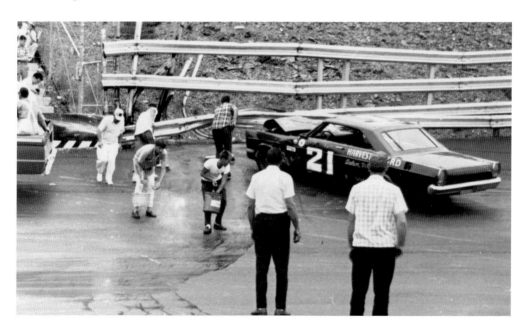

MARVIN PANCH'S CHAMPIONSHIP HOPES and the front end of his Ford, owned by brothers Glen and Leonard Wood, took a hard hit during the 1965 Volunteer 500. Panch entered the race third place in points and qualified fifth quickest, but a lap eight tangle with David Pearson's Dodge parked both cars for the day. Here track safety workers attend to fluid from Panch's radiator and damage to the Turn 4 guardrail. (Courtesy of the Carl Moore collection.)

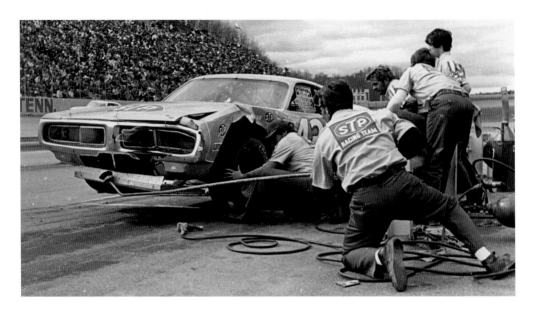

CREW MEMBERS CHANGE TIRES, CLEAN DEBRIS away from the opening to the radiator, and attend to front-end damage on Richard Petty's Dodge Charger. During one amazing five-race stretch in the early 1970s, Petty posted three second-place finishes and ran third twice. In 1975, he became the fifth different driver to win both races in a single season. (Photograph by John Beach.)

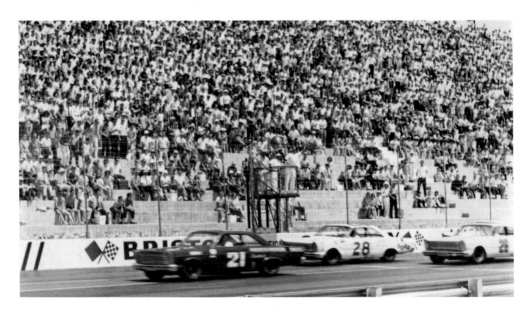

MARVIN PANCH (21) LEADS FRED LORENZEN (28) and Bobby Isaac (26) during a restart in the 1966 Southeastern 500. The race ended early for all three, as Panch and Lorenzen suffered engine problems and Isaac was involved in a crash. (Courtesy of the Carl Moore collection.)

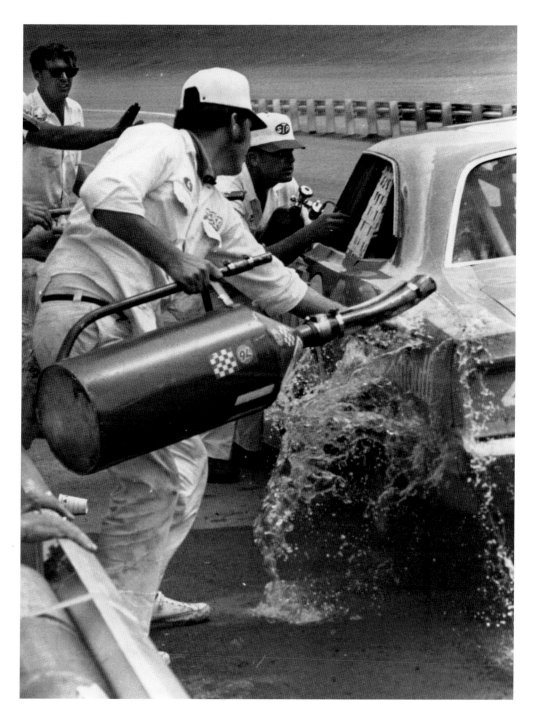

BEFORE TODAY'S DRY-BREAK FUEL systems and overflow valves, fueling a stock car was a dangerous job. Here gasoline spills back out of Richard Petty's Plymouth during the 1970 Volunteer 500. Note the hand and facial communication between the crew and driver. (Photograph by John Beach.)

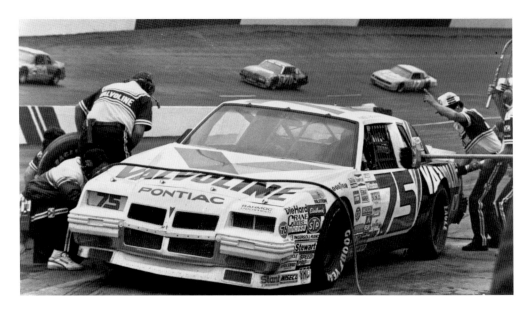

THE RAHMOC TEAM CHANGES right-side tires and adds fuel to Neil Bonnett's Valvoline Pontiac during the 1987 Valleydale Meats 500. Bonnett was one of the pre-race favorites after qualifying 10th quickest but finished 11th, one spot behind rookie Dale Jarrett and just ahead of former teammate Darrell Waltrip. (Photograph by David McGee.)

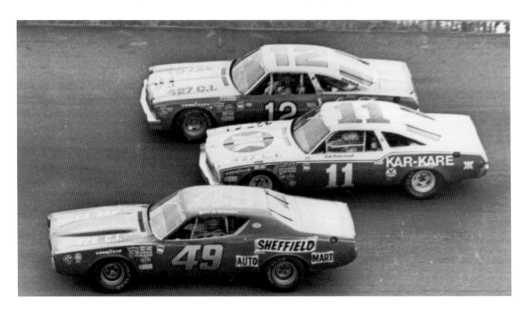

BOBBY ALLISON (12) AND CALE YARBOROUGH (11) race side by side through Turns 1 and 2 as G. C. Spencer (49) stays low in the 1973 Volunteer 500. Both Allison and Yarborough took turns leading the race, but they crashed together in Turn 3 on lap 342. Spencer dropped out with transmission trouble, and Benny Parsons went on to win. (Photograph by John Beach.)

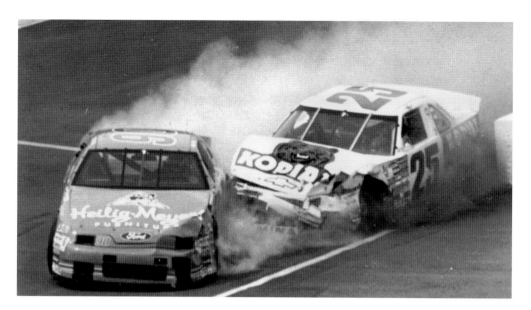

KEN SCHRADER (25) SAW HIS three-race streak of third-place Bristol finishes come to a grinding halt on lap 52 of the 1993 Food City 500. With no place to go, Schrader's Chevy slammed into the Ford of Bobby Hillin (90). Hillin's team, owned by Junie Donlavey, made repairs and returned to the race but retired on lap 119 with a broken oil pump. (Photograph by David McGee.)

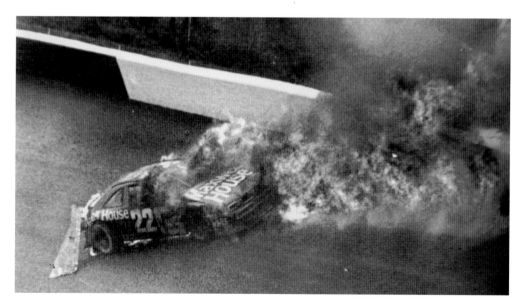

STERLING MARLIN'S FORD BURSTS into flames after hard contact with the Turn 1 concrete wall on lap 422 of the 1991 Valleydale Meats 500. Marlin was hospitalized with second- and third-degree burns but returned to the driver's seat the next week. (Photograph by David McGee.)

BRISTOL MOTOR SPEEDWAY

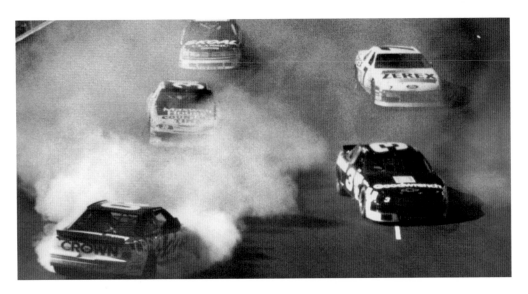

WINSTON CUP ROOKIE ROB MOROSO (20) steams backwards toward the Turn 1 wall during the 1990 Busch 500. At that point in the race, Dale Earnhardt (3) was leading, and Alan Kulwicki (7) ran second. Also pictured are Michael Waltrip (30) and Terry Labonte (1). Earnhardt relinquished the lead after suffering a cut tire, and Ernie Irvan captured the win. It would be Moroso's final Bristol appearance, as the 22-year-old driver died in a highway crash a month later. (Photograph by David McGee.)

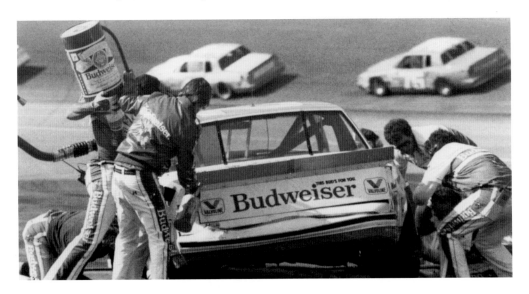

JOHNSON-HODGDON RACING CREW MEMBERS service Neil Bonnett's No. 12 Budweiser Chevy as the lead pack roars into Turn 1 during the 1984 Valleydale 500. Bonnett pitted after reporting a vibration. He finished 11th in the 30-car field, one spot ahead of rookie driver Rusty Wallace. Teammate Darrell Waltrip picked up the win before a crowd of about 27,000. (Photograph by David McGee.)

NON-STOP ACTION

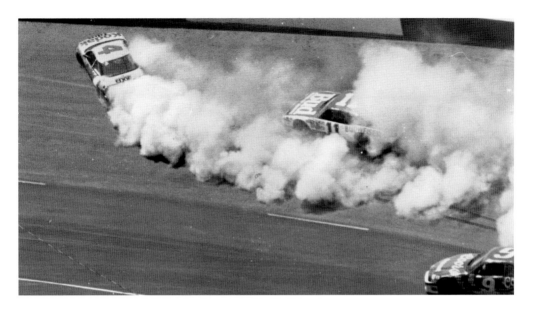

IT ISN'T A KODAK MOMENT for Rick Wilson (4), who slides up the banking in Turn 2 during the 1988 Valleydale 500. Wilson earned the first career pole for himself and Morgan-McClure Motorsports and led the race's first 21 laps. The team made repairs, but Wilson was involved in three other accidents before the day would end. Bill Elliott (9) took evasive measures and scored his only career short-track win that day. (Photograph by David McGee.)

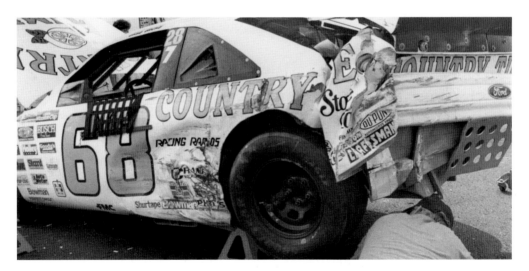

THE 1993 BUD 500 WEEKEND got off to a rocky start for Greg Sacks, who backed the George Bradshaw–owned Country Time Ford into Bristol's unforgiving walls during practice. The team rolled out the backup car, qualified 28th, and finished 19th, one spot ahead of rookie driver Jeff Gordon. Note the No. 28 and No. 7 decals on the car's B-pillar to honor Davey Allison and Alan Kulwicki, who perished in separate aircraft accidents that season. (Photograph by David McGee.)

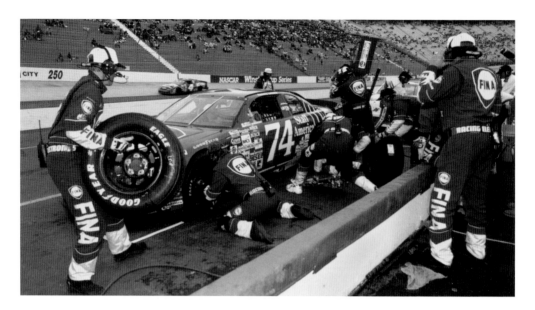

A CREW MEMBER ON RANDY LaJoie's No. 74 Chevrolet waits to hand off the left front tire during pit stop action in the 1997 Moore's Snacks 250 Busch Series race. Though the crew member apparently handles it with ease, the inflated tire and wheel weigh more than 50 pounds. LaJoie, a two-time series champion, led once during the afternoon and finished third behind Jeff Burton and Mike McLaughlin. (Photograph by David McGee.)

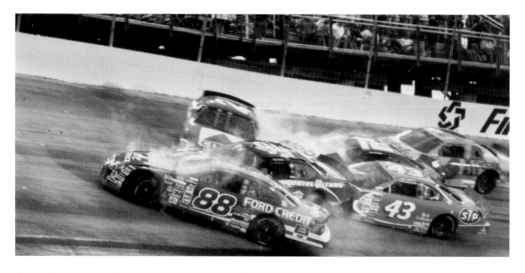

CARS CIRCLE THE BRISTOL TRACK so quickly that drivers often get caught up in someone else's wreck. A total of seven cars were eventually involved in this crash during the 1999 Goody's 500. Bill Elliott's McDonald's Ford (94) was the meat in the hamburger as Dale Jarrett (88) and Elliott Sadler (21) spun in different directions in Turn 1. Also involved were John Andretti (43), Jeremy Mayfield (12), Bobby Hamilton (4), and Hut Stricklin (not pictured). (Photograph by Chris Haverly.)

NON-STOP ACTION

PIT STOPS AT BRISTOL mean close quarters for both cars and people. At the 2000 Food City 500, Matt Kenseth (17) pulls around the crew members of Michael Waltrip (7) as both take on four new tires and get 22 gallons of fuel in less than 15 seconds. Moments later, Waltrip must avoid Kenseth's car and crew members to pull out of his pit stall. On this day, Waltrip finished 11th and Kenseth 12th. (Photograph by David McGee.)

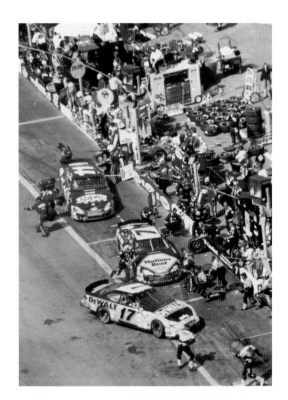

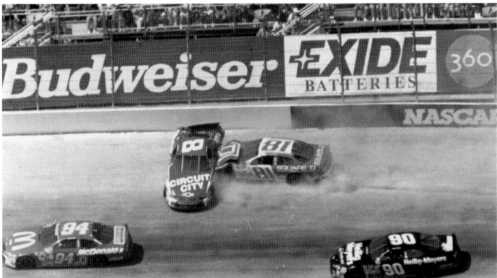

KENNY WALLACE (81) SLAMS into the driver's side of Hut Stricklin's No. 8 Chevrolet on lap 156 of the 1998 Food City 500. Wallace's Ford was too badly damaged to continue, and Stricklin retired his entry after attempting to make repairs. Meanwhile, the Fords of Bill Elliott (94) and Dick Trickle (90) stay low on the race track to avoid the crash. Trickle finished 13th and Elliott 15th that day. (Photograph by David McGee.)

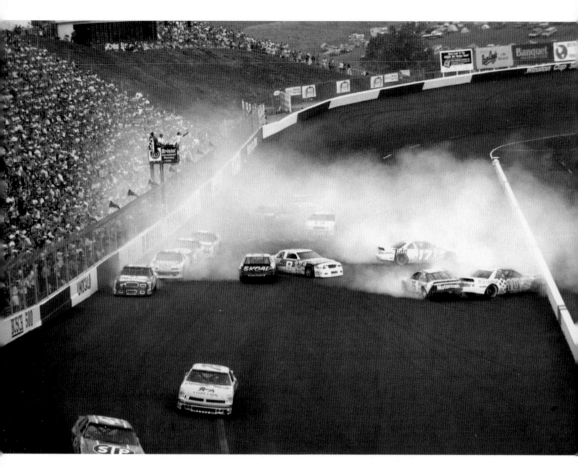

DERRIKE COPE (10) SLAMS INTO the inside retaining wall at the start/finish line after a multi-car crash that momentarily blocks the front straightaway in the 1990 Busch 500. Also spinning were Darrell Waltrip (17), Morgan Shepherd (15), and Bobby Hillin (8), while the cars of Hut Stricklin (12) and Harry Gant (33) also made contact. Richard Petty (43) and Rick Wilson (75) watched the melee unfold in their rearview mirrors. The accident happened after Rick Wilson suffered engine damage in his Oldsmobile. The incident ruined the night for everyone involved, as none were able to salvage a top-20 finish. Note the height of the flagman's vantage point overlooking the racetrack. In Bristol's early days, when the banking was lower and the infield was less crowded, the flagstand was much lower. In the years since, it has been raised for the safety of the flagman and to give the officials a better view of the entire racing surface. (Photograph by David McGee.)

MARK MARTIN'S HOPES FOR THE 1992 championship took a decimating hit during the August Bud 500. After leading twice, he was involved in a multi-car crash. Here Martin limps his Valvoline Ford back to the pits trailing a shower of sparks in his wake, as pieces of the car drag on the track's new concrete surface. (Photograph by David McGee.)

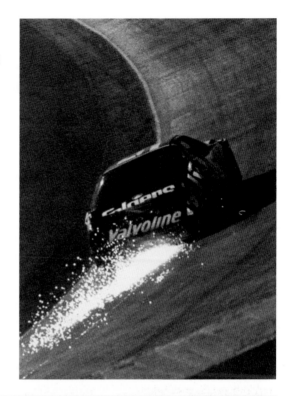

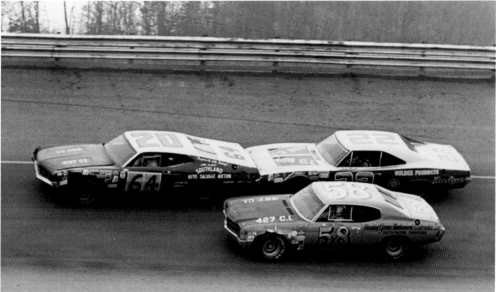

ELMO LANGLEY (64) GETS A BUMP from Dick Brooks (22) as they battle for position during the 1971 Southeastern 500. Brooks eventually got by and raced to a third-place finish, while Langley wound up seventh in a car borrowed from Jimmy McCain. Robert Brown's Chevelle (58), down one lap, stays on the bottom. (Courtesy BMS archives.)

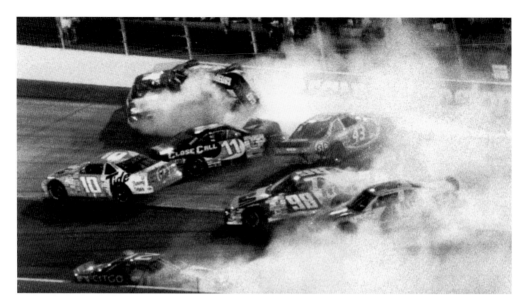

AMAZINGLY, THREE DRIVERS PICTURED in this wild seven-car crash on the front stretch returned to post top-20 finishes during the 1997 Goody's 500. Ricky Rudd (10), John Andretti (98), and Sterling Marlin (4) avoided much of the mayhem. David Green (22), whose car is on its side and mostly obscured by smoke at the top of the frame, finished a disappointing 40th. It was also a long night for the others involved—Michael Waltrip (21), Bobby Hamilton (43), and Brett Bodine (11), whose sponsor, Close Call, seems apt for BMS. (Photograph by David McGee.)

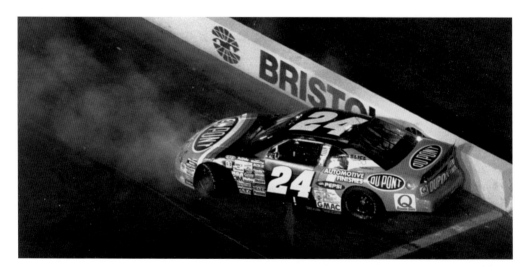

JEFF GORDON LOCKS UP the brakes and skids into the backstretch concrete wall. Gordon and Jeremy Mayfield got together on lap 245 of the 1997 Goody's 500 night race. Gordon won that spring's race and qualified second fastest in August but was forced to settle for a 35th place finish that night. Mayfield wound up 30th. (Photograph by David McGee.)

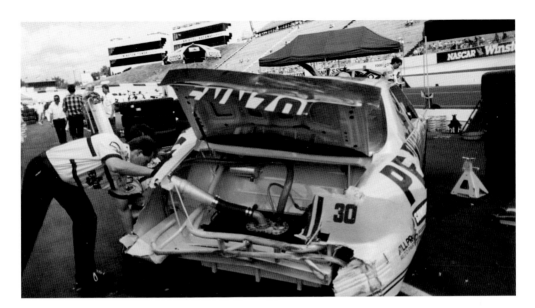

A BAHARI RACING CREW MEMBER surveys the damage after Michael Waltrip backed his Pennzoil Pontiac into the outside wall during final practice for the 1992 Bud 500, the first race on the track's concrete surface. Waltrip's team rolled out the backup car, forcing them to start at the rear of the 32-car field. Despite the handicap, Waltrip made a solid run to finish 14th on the night his older brother, Darrell, captured his final Bristol victory. (Photograph by David McGee.)

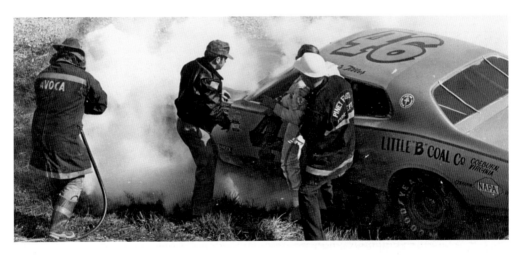

FIREFIGHTERS RUSH TO EXTINGUISH a blaze beneath the Dodge of Virginia driver Travis Tiller. The fire was caused by an engine failure that parked the machine on lap 295 of the 1976 Southeastern 400. Tiller wound up 18th in the running order after being involved in four of the race's six caution periods. The race was also the first of three at Bristol shortened by 100 laps, so what was the Southeastern 500 became the Southeastern 400. (Courtesy of BMS archives.)

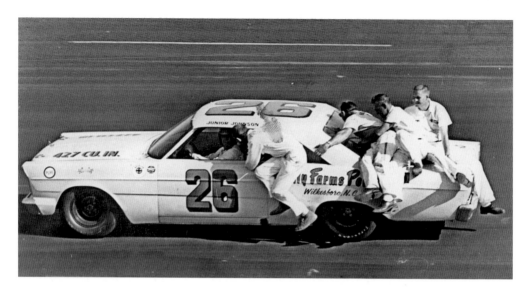

CREW MEMBERS FOR JUNIOR JOHNSON pile on his Holly Farms–backed Ford for a ride to victory lane. The speedway's most successful car owner earned only one win as a driver, in the 1965 Southeastern 500. Johnson needed relief help from Fred Lorenzen midway through the race and recovered from a blown tire to hold off Dick Hutcherson and Ned Jarrett. Fords claimed the top six spots in that race. (Courtesy of BMS archives.)

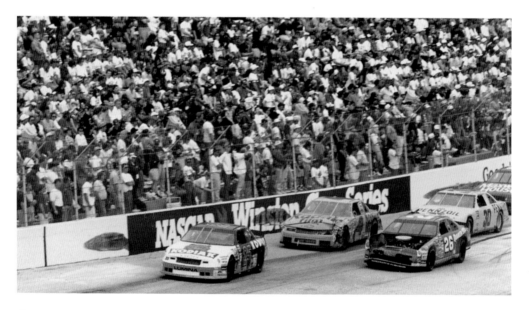

CRASHES ASIDE, FANS CONSISTENTLY pack into the stands at Bristol to watch tight packs of cars racing inches apart. Here, during the 1994 Food City 500, Ken Schrader (25), Sterling Marlin (4), and Michael Waltrip (30) work past the lapped car of Brett Bodine (26). Schrader finished second behind Dale Earnhardt, while Waltrip finished fifth and Marlin eighth. Bodine finished 13th in the 37-car field. (Photograph by David McGee.)

NON-STOP ACTION

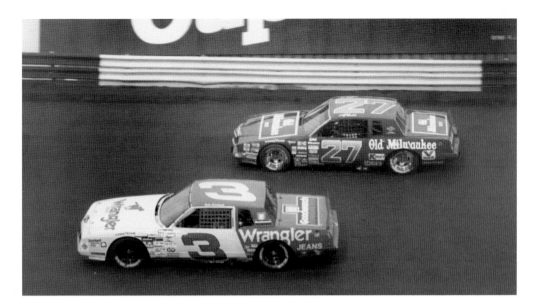

THE 1985 BUSCH 500, which featured an epic battle between Dale Earnhardt (3) and Tim Richmond (27), was the first night race broadcast live on ESPN, the national sports programming network. Then a novelty, the race brought the rough-and-tumble Bristol action to a prime-time television audience. (Courtesy of BMS archives.)

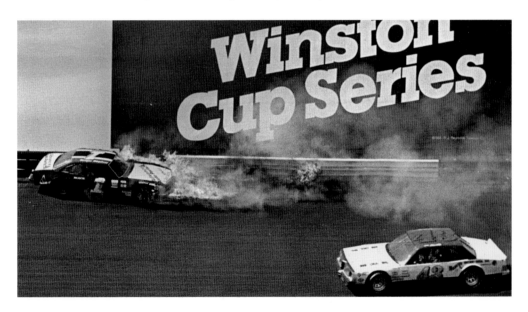

THE PONTIAC OF MORGAN SHEPHERD (1) trails fire after an oil line came loose when he slammed into the guardrail between Turns 1 and 2 during the 1985 Budweiser 250 Busch Series race. The accident spoiled another good run for Shepherd, who won three Busch Series races at BMS during the early 1980s. Darrell Waltrip picked up his only BMS Busch Series win in that event. (Photograph by Earl Neikirk.)

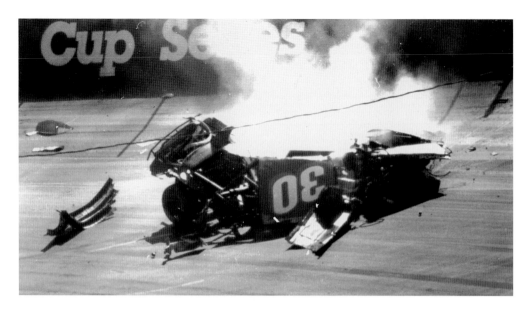

MICHAEL WALTRIP'S CAR WAS REDUCED to a smoldering, broken pile of metal after a vicious Turn 2 crash during the 1990 Budweiser 250. The car struck a gate and the end of the concrete wall, which broke the chassis and rollcage. The stunned crowd sat silently for several minutes before Waltrip emerged unscathed. (Photograph by David McGee.)

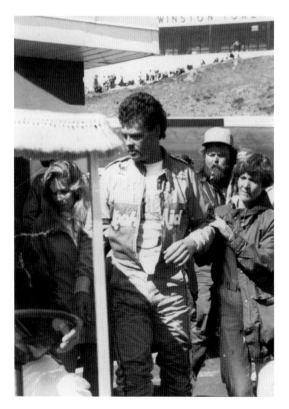

HERE WALTRIP, AIDED BY EMERGENCY workers, walks away from the scene of what is widely regarded as one of the worst crashes in racing history. The remains of the car are now on display in the International Motorsports Hall of Fame in Alabama. (Photograph by John Beach.)

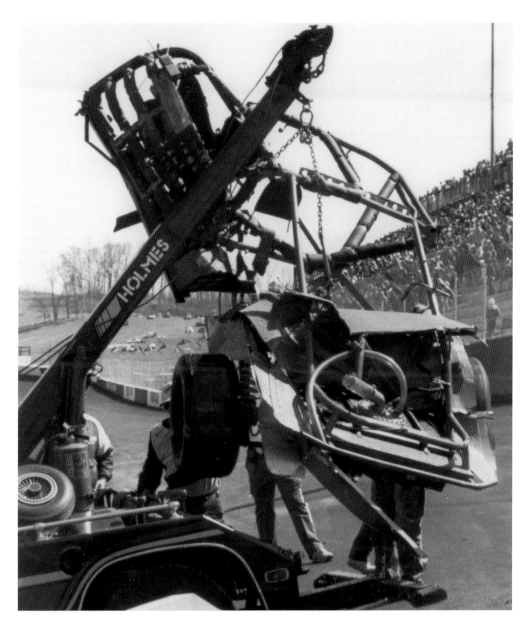

A WRECKER LIFTS A SECTION of what remains of Waltrip's car following the crash. The car's body was sheared off and this section of the roll cage and the rear of the chassis broke away from the remainder of the car. The engine was hurled out during the crash, and a section of the roll cage was embedded into the gate area. When Waltrip tried to stand up, his feet touched the race track because the floor panel was torn away. "Anybody who looked at the video probably can't understand how I survived," Waltrip said the following day. "I just figured it wasn't my time to go. I still have a lot of racing to do." Waltrip competed in the Sunday Cup race later that day and has continued to race, picking up four Cup series wins through the 2005 season. (Photograph by John Beach.)

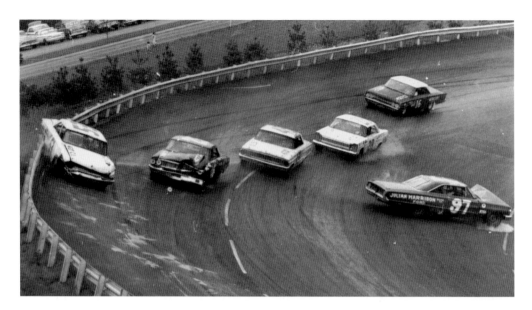

IN THE TOP PHOTOGRAPH, Jimmy Helms (53) rides the Turn 4 guardrail in his Ford after contact with E. J. Trivette (97) and Jabe Thomas (25) during the 1965 Volunteer 500. Behind them, a pack of drivers slam on the brakes and prepare to take evasive measures. Seconds later, in the bottom photograph, a spring and shock absorber from Jimmy Helms's car bounce across the track, as Jabe Thomas turns down in front of the other cars. Note the trail of water from Thomas's Ford and the puddle beneath E. J. Trivette's machine. (Courtesy of BMS archives.)

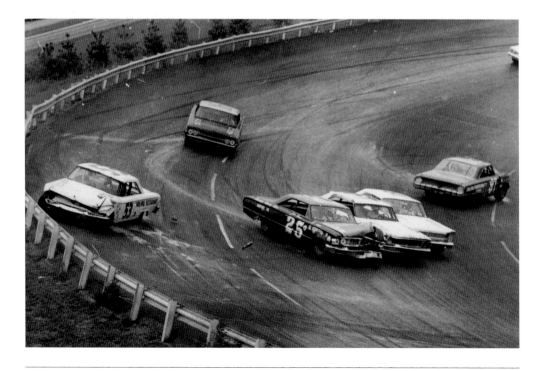

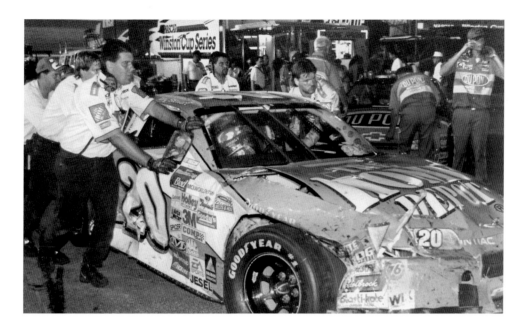

CREW MEMBERS PUSH TONY Stewart's battered Home Depot Pontiac back to the pits after the 1999 Goody's 500. Despite the obvious damage to the car's front end and right side, Stewart brought the car home in fifth place, leading the most laps in the race after starting on the pole. Two years later, Stewart drove to victory lane with a win in the night race. (Photograph by Chris Haverly.)

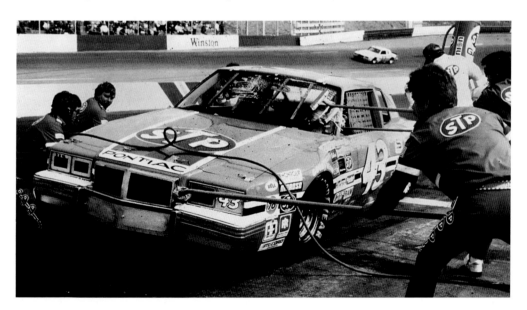

CREW MEMBERS REPLACE FOUR TIRES, refuel, and clean debris from the front of Richard Petty's STP Pontiac during the 1985 Valleydale 500. Petty started 15th and finished 8th in the 30-car field, thanks in part to fast pit stops. (Photograph by David McGee.)

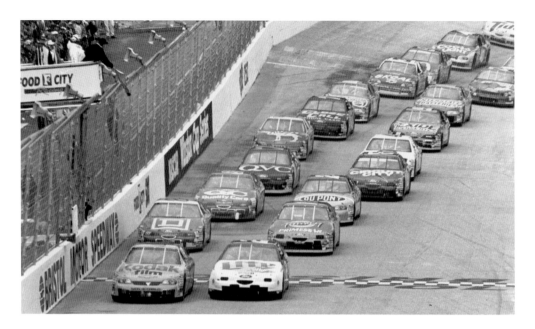

THE 43-CAR FIELD TAKES the green flag for the 1997 Food City 500. With Bristol's limited real estate, the front row of Sterling Marlin (left) and Rusty Wallace (right) cross the start/ finish line while the rear of the pack is still in Turn 3. The two-by-two symmetry and good manners usually last for only a few moments. (Photograph by David McGee.)

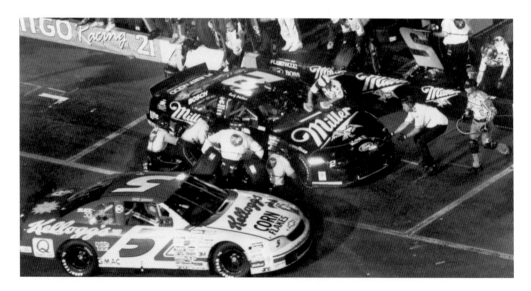

MUCH LIKE DRIVERS RACE on the track, crew members compete to see who can provide the fastest service on pit road. Less time spent in the pits translates into better position on the track. Here the crew for Rusty Wallace (2) changes right-side tires as competitor Terry Labonte (5) pulls into his pit stall during the 1996 Goody's 500. Wallace would later take the win, with Labonte finishing fifth. (Photograph by David McGee.)

NON-STOP ACTION

R I V A L R I E S

*I passed him down the front straightaway and he hit me. He never has any intention
of taking anybody out, it just happens that way.*

—Terry Labonte

I didn't mean to turn him around. I just wanted to rattle his cage a little bit.

—Dale Earnhardt

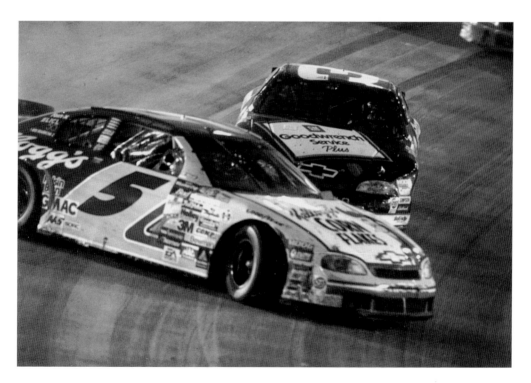

TERRY LABONTE (5) STRUGGLES to control his
spinning car after contact by Dale Earnhardt
(3) on the last lap of the 1999 Goody's 500.
Earnhardt went on to win for the ninth time
at BMS, but the accident divided the huge
crowd, with many of the fans cheering wildly
but the majority voicing their displeasure.
(Courtesy of BMS archives.)

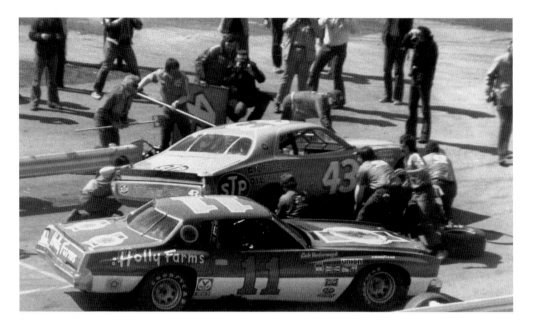

DURING THE 1970S, NO ONE challenged Richard Petty's (43) superiority more than Cale Yarborough (11) and Junior Johnson. And nowhere was that more obvious than on short tracks like Bristol, where Yarborough won eight races in six seasons. The only year the No. 11 failed to win at Bristol was 1975, when Petty won both races. The two men combined for eight NASCAR championships during that decade. (Photograph by Mike O'Dell.)

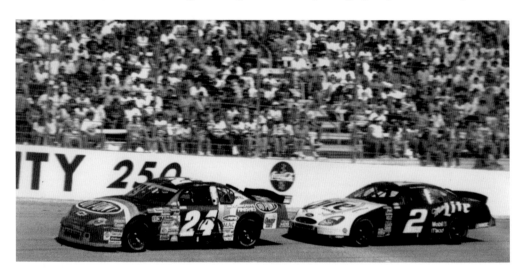

LONGTIME RIVALS JEFF GORDON (24) and Rusty Wallace (2) got together again during the 2000 Food City 500. Gordon started third and led the most laps that day, but Wallace persevered, took the lead from Dale Jarrett on lap 424, and went on to earn his 50th career NASCAR victory. Through 2005, Gordon and Wallace combined for 14 BMS wins. (Photograph by Chris Haverly.)

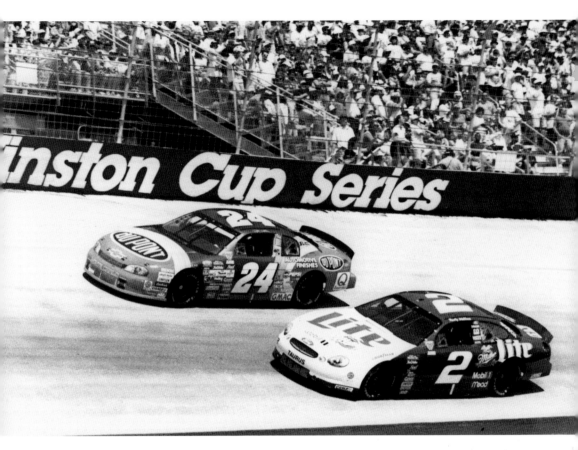

TWICE DURING HIS FOUR-RACE Food City 500 winning streak, Jeff Gordon (24) used some aggressive moves to get around Rusty Wallace (2). Those aggressive moves resulted in some harsh words from Wallace, so when the two raced side-by-side in 1998, fans expected some retaliation. What they saw instead was Gordon passing cleanly en route to a fourth straight win. (Photograph by Chris Haverly.)

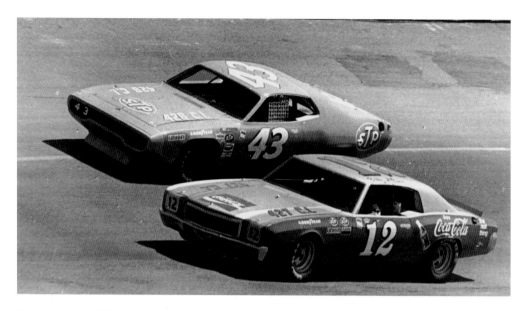

DURING THE 1972 SEASON, there were no greater rivals than Richard Petty (43) and Bobby Allison (12). Allison won more races (10) and poles (11) than Petty, but the STP Plymouth carried Petty to his second straight Winston Cup title. Allison dominated Bristol that season, winning both races from the pole, and led almost 900 of the combined 1,000 laps. (Photograph by John Beach.)

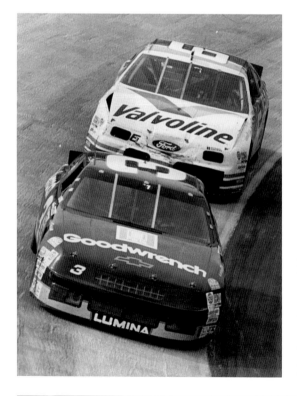

DALE EARNHARDT (3) AND MARK MARTIN (6) battled for race wins and Winston Cup championships during the 1990s. Here in the 1993 Bud 500, Martin made up two laps and went on to win over Rusty Wallace. Earnhardt, who started 19th, had to settle for third place. (Photograph by David McGee.)

RIVALRIES

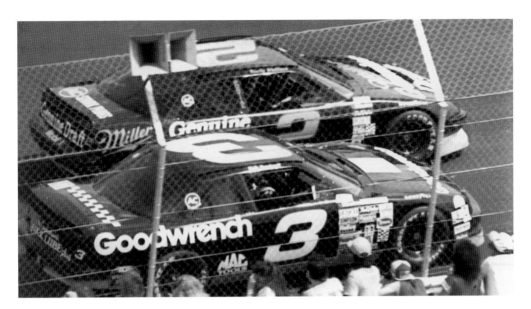

THE BRISTOL FANS ALWAYS LOVED it when Rusty Wallace (2) and Dale Earnhardt (3) raced side by side with each other. Here, in the 1991 Valleydale Meats 500, Wallace led 10 different times en route to winning by a foot over Ernie Irvan. Earnhardt qualified second and ran well early, but an accident left him out of contention by the race's end. (Photograph by Mike O'Dell.)

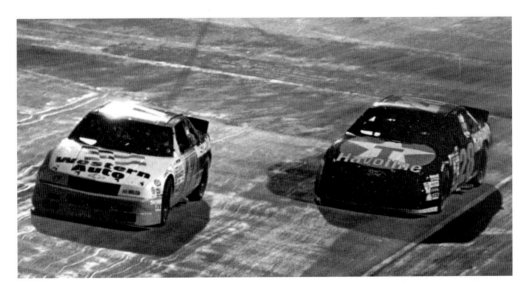

DARRELL WALTRIP (17) PASSES DAVEY ALLISON (28) en route to his 12th and final Bristol win on August 29, 1992. Before the race, Waltrip warned the competition he needed to win because he had another mouth to feed. His daughter Sarah was born four nights prior. The race also marked the first on the current concrete surface and the first time tire maker Goodyear supplied radial tires at Bristol. (Photograph by David McGee.)

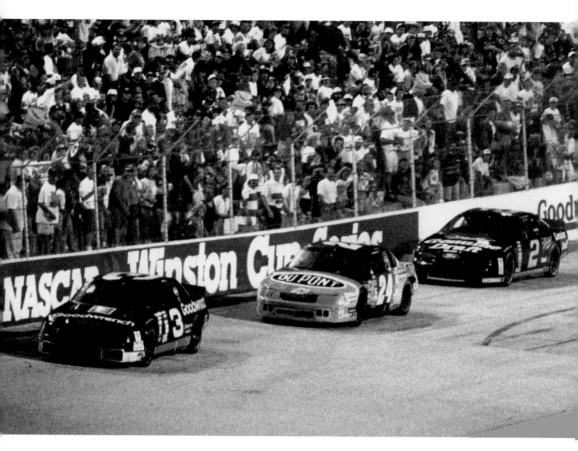

FANS AT BRISTOL WERE OFF their seats and screaming any time these three got close to each other. Dale Earnhardt (3), Jeff Gordon (24), and Rusty Wallace (2) staged some epic Bristol battles. Here they are racing for position during the 1994 Goody's 500 night race. Wallace would eventually drive his Ford to victory lane, while Earnhardt wound up third behind Mark Martin and Gordon dropped out after an accident. (Photograph by David McGee.)

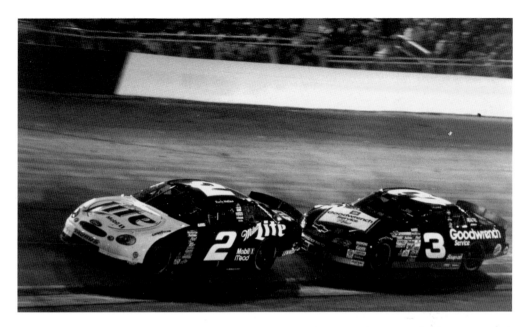

LONGTIME FRIENDS AND RIVALS Rusty Wallace (2) and Dale Earnhardt (3) race during the 1999 Goody's 500. Later that night, Earnhardt would make his ninth and final trip to Bristol's victory lane. Both began their careers with Bristol wins, and they combined for 18 at the World's Fastest Half Mile. (Photograph by Chris Haverly.)

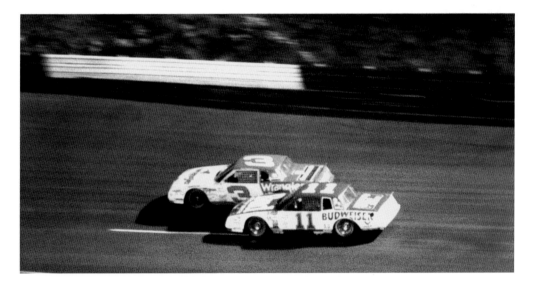

IN THE EARLY 1980s, Darrell Waltrip (11) and Dale Earnhardt (3) battled to see who was the king of Bristol, the standard-bearer for Chevrolet, and the eventual Winston Cup champion. Waltrip won at Bristol nine times between 1980 and 1989, while Earnhardt won six times. Each also won three championships during that period. Here they battle during the 1985 night race eventually won by Earnhardt. (Photograph by John Beach.)

BILL ELLIOTT (9) TRIES TO HOLD off Darrell Waltrip (11) as they battle for a top-five spot in the 1986 Valleydale Meats 500. Elliott finished in a solid fifth place that afternoon, two spots behind Waltrip's Chevrolet. The two champions combined for five wins that season, as both finished in the top four in the Winston Cup points standings. (Courtesy of BMS archives.)

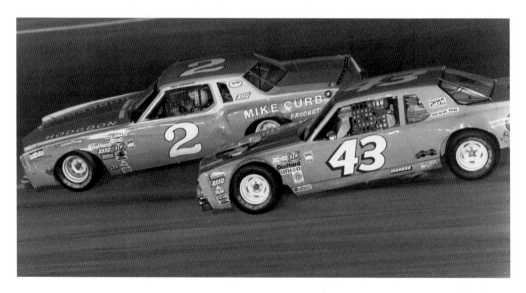

DALE EARNHARDT (2) RACES Richard Petty (43) during the 1980 Busch 500. Both champions took turns leading laps in their Chevrolets, but Earnhardt eventually finished in second place, one second behind winner Cale Yarborough. Petty finished in fourth place, one lap behind the leaders. (Courtesy of BMS archives.)

RIVALRIES

RECORDS AND MILESTONES

I don't think anyone will ever be able to win seven straight at Bristol again.
It's such a demanding track, you'd be lucky just to finish seven straight.

—Jeff Gordon

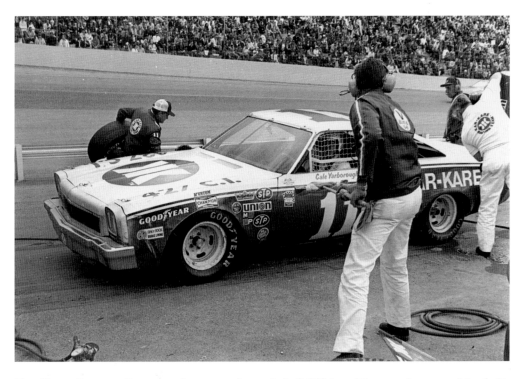

THE CREW QUICKLY PREPARES the car so that driver Cale Yarborough can get out of the pits and back onto the track during the 1973 Southeastern 500. In a record that may never be broken, Yarborough started on the pole and led all 500 laps. The race began on March 11, but heavy rains forced a postponement after only 52 laps had been run. Teams returned two weeks later, and Yarborough cruised to victory. (Photograph by John Beach.)

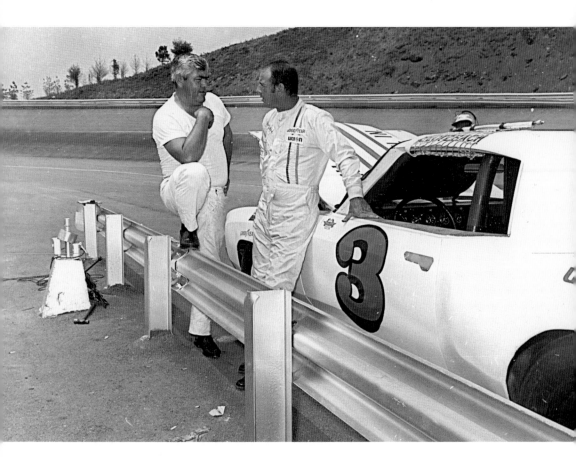

CAR OWNER JUNIOR JOHNSON (left) and driver "Chargin' Charlie" Glotzbach discuss strategy prior to the 1971 Volunteer 500. The race marked a competitive return by Chevrolet to NASCAR Winston Cup racing. Glotzbach qualified on the front row and established a race-winning speed record that may stand forever. He won the race, which was run without a single caution period, with an average speed of 101.074 miles per hour. (Photograph by John Beach.)

DAVID PEARSON ACCEPTS THE TROPHY for winning the 1971 Southeastern 500. While it was the "Silver Fox's" final Bristol win, it marked the track's first race for NASCAR's new corporate partner, the R. J. Reynolds Tobacco Company. NASCAR's top division was known as the Winston Cup Series for 33 years. (Courtesy of the Carl Moore collection.)

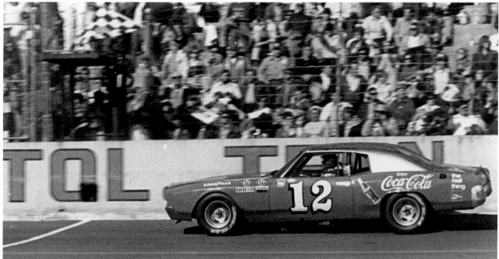

A PACKED HOUSE TURNED OUT to watch Bobby Allison dominate the 1972 Southeastern 500. Allison, in his only season driving for Richard Howard and Junior Johnson, qualified on the pole and led 445 of the 500 laps. Remarkably, the team would virtually replicate that performance in July, qualifying fastest and leading 445 laps for the win. Allison also became the first of three drivers to win both Bristol races from the pole in a single season. (Photograph by John Beach.)

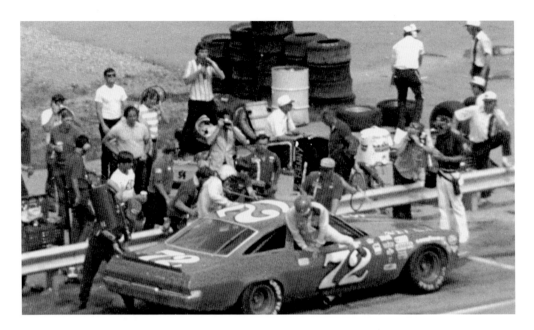

BENNY PARSONS AND JOHN A. UTSMAN perform a driver change during the 1973 Volunteer 500. Run on a sweltering July afternoon, the tandem combined to lead the final 169 laps and won by 7 laps, equaling the largest margin in BMS history. The race marked Parsons's lone victory in his run to that season's Winston Cup championship. (Photograph by Mike O'Dell.)

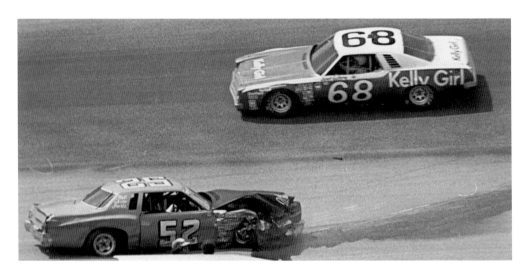

JANET GUTHRIE (68) BECAME THE FIRST female to compete in the Winston Cup division at Bristol. Shown here passing Jimmy Means (52) in the 1977 Volunteer 400, Guthrie posted a sixth-place finish, 13 laps off the pace of winner Cale Yarborough. Earlier that season, she and relief driver Rick Newsom combined to finish 11th in her first trip to Bristol. (Courtesy of BMS archives.)

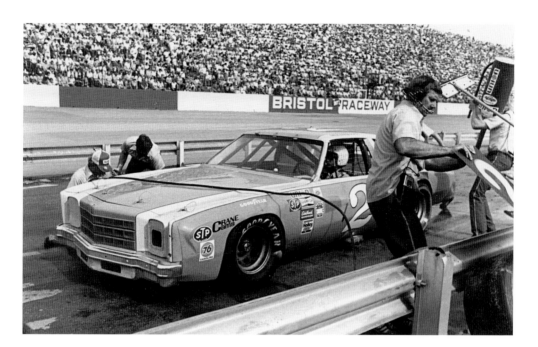

SOME 26,000 PEOPLE WERE IN the stands on April 1, 1979, when Dale Earnhardt notched his first NASCAR Winston Cup victory in the Southeastern 500 at Bristol. Here members of the Rod Osterlund–owned team change tires and add fuel to Earnhardt's Chevrolet. He would go on to win 75 more times and earn 7 Winston Cup titles. (Courtesy of BMS archives.)

NEIL BONNETT WALKS TO HIS pole-winning Chevrolet prior to the start of the 1983 Valleydale 500. The traditional spring race was moved to May 21 and contested under the lights. It marked the only time the track's first race ran into the night. (Courtesy of BMS archives.)

BRISTOL MOTOR SPEEDWAY

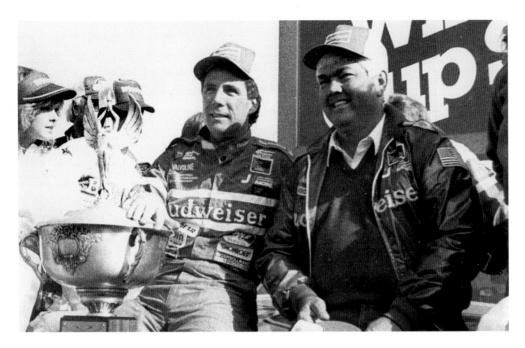

On April Fools' Day 1984, Darrell Waltrip (left) and car owner Junior Johnson captured their seventh consecutive race win together on the World's Fastest Half Mile. Waltrip led five times that day, including the final 44 laps to the checkered flag. Ricky Rudd finished second and Bobby Allison third. The Waltrip-Johnson streak began in March 1981 and stands as the longest win streak in track history. (Photograph by David McGee.)

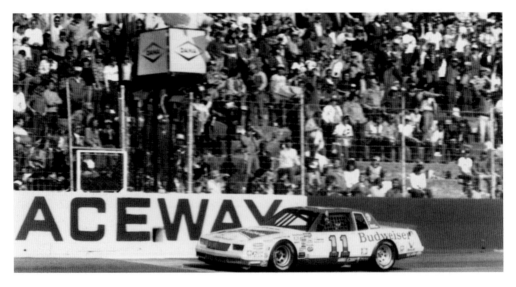

Darrell Waltrip Flashes under the checkered flag, signifying his victory in the 1984 Valleydale 500. The race marked Waltrip's seventh straight Bristol win. (Photograph by John Beach.)

RECORDS AND MILESTONES

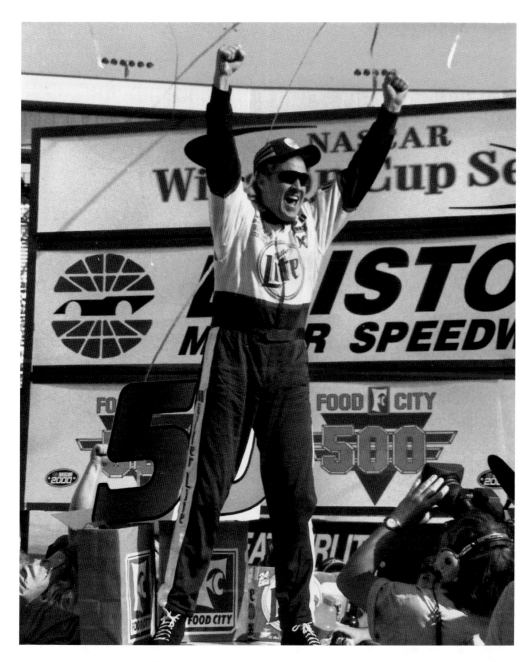

AN ECSTATIC RUSTY WALLACE celebrates his 50th career Winston Cup win at Bristol, where he also picked up his first. Wallace has always called Bristol his favorite track, and the bookend wins, plus seven others, are a testament why. In 2000, Wallace won both the Food City 500 and the August Goracing.com 500, his only season sweep at Bristol. (Photograph by Chris Haverly.)

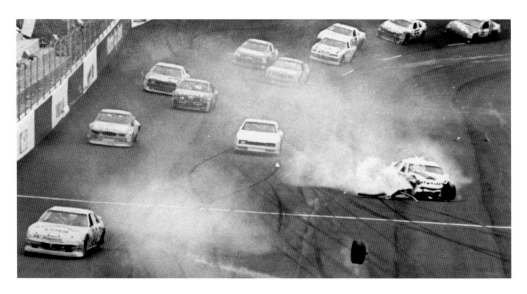

THE RIGHT FRONT TIRE from Morgan Shepherd's Pontiac bounces down the front stretch after Shepherd made hard contact with the outside wall. This crash happened on lap 234 of the 1989 Valleydale 500 and brought out one of 20 caution periods that day. That stood as a NASCAR record for several years and, through 2005, remains the track record for yellows. (Photograph by David McGee.)

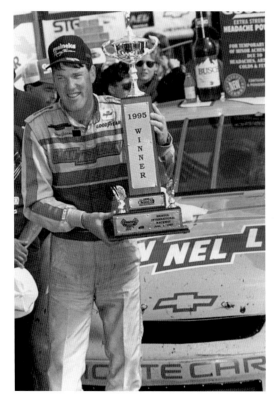

STEVE GRISSOM BECAME THE FIRST and only (through 2005) NASCAR Busch Series driver to win both Bristol races in a single season. Grissom, a former standout football player, drove Gary Bechtel's Channellock Chevrolet to wins in the Goody's 250 and Food City 250 during the 1995 season. Ironically, the team failed to finish the season, and the 1993 series champ finished out of the top 20 in points. (Photograph by David McGee.)

RECORDS AND MILESTONES

6

CAR OWNERS AND CREWS

Over the years I tore up a lot of cars here. As a car owner, it's still the same kind of thing. You worry about tearing your cars up, but Bristol does that to a lot of cars. It's always been great for the fans. People love it because they can see everything and they like the action.

—Richard Petty

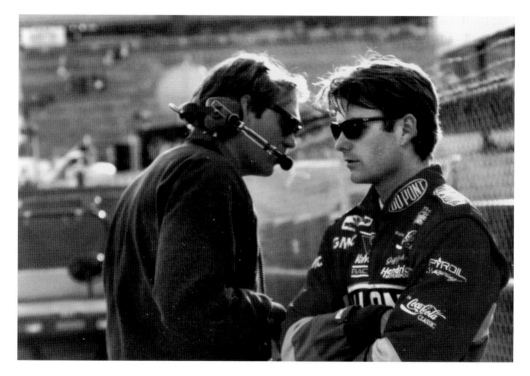

JEFF GORDON (RIGHT) CONFERS with then–crew chief Ray Evernham during practice for the 1995 Goody's 500. During their eight seasons working together, the pair captured four consecutive Food City 500s in 1995, 1996, 1997, and 1998. The team, owned by Rick Hendrick, won three Winston Cup championships during that span. With Evernham calling the shots, Gordon scored 4 wins, 3 top-5, and 10 top-10 finishes in 16 Bristol starts from 1993 through 2000. (Photograph by David McGee.)

JUNIOR JOHNSON (LEFT) CONFERS with Darrell Waltrip after Waltrip bounced off the outside wall during Saturday practice for the 1984 Valleydale 500. Johnson's crew repaired the damage and Waltrip went on to post his seventh straight Bristol win. The dominance took its toll on race fans, many of whom wore "Anyone but Waltrip" T-shirts. (Photograph by David McGee.)

FORMER CREW CHIEF ROBERT YATES has continued to take a hands-on role as a car owner. Here he closely inspects the carburetor of his No. 28 Ford prior to the 1997 Food City 500. Yates has won twice at Bristol as a car owner, with Davey Allison in the 1990 Valleydale 500 and Dale Jarrett in the Goody's 500. (Photograph by David McGee.)

CREW CHIEF TONY GLOVER studies data on a computer during practice at Bristol. The son of former NASCAR Sportsman Series champion Gene Glover, Tony grew up less than 20 miles from Bristol. After working for Richard Petty, he became crew chief for the locally based Morgan-McClure race team. Together the team earned its first career win at Bristol in August 1990. Tony left that team in 1996 to become crew chief at Sabco Racing. He later became team manager for subsequent owner Chip Ganassi. (Photograph by David McGee.)

YATES RACING CREW CHIEF Larry McReynolds (right) listens to driver Ernie Irvan during practice for the 1994 Food City 500. In their first Bristol start together, Irvan qualified seventh in the 37-car field but completed only 167 laps before engine failure ended their day. Irvan was seriously injured later that season but returned to the cockpit of the No. 28 in 1996. (Photograph by David McGee.)

CREW CHIEF LARRY MCREYNOLDS (right) studies his setup notes while talking with substitute driver Kenny Wallace prior to the 1994 Goody's 500. Wallace was called into service after Ernie Irvan was critically injured the week before during a practice crash in Michigan. Despite the circumstances, Wallace qualified 15th in the 36-car field and finished 13th, one lap off the pace of his older brother Rusty, who captured the win. (Photograph by David McGee.)

CAR OWNERS AND CREWS

CAR OWNER JOE GIBBS (left), driver Bobby Labonte (center), and crew chief Jimmy Makar talk about the team's great fifth-place qualifying effort for the 1995 Food City 500, their first Bristol start together. Some poor Bristol racing luck left the team with a disappointing 32nd-place finish. In 11 seasons together, Labonte and Gibbs teamed for seven top-10 BMS finishes. (Photograph by David McGee.)

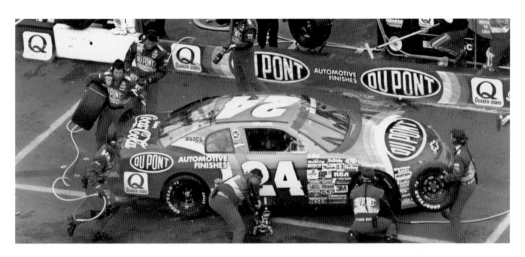

THROUGHOUT NASCAR'S HISTORY, QUICK pit stops have helped drivers win countless races, but during the mid-1990s, car owner Rick Hendrick and crew chief Ray Evernham revolutionized pit stops forever with the "Rainbow Warriors." Hendrick hired a special raceday-only group of athletes whose sole job was to pit Jeff Gordon's Chevrolets. A decade later, nearly all teams have pit crew coaches and regular workout schedules, and they can provide more efficient pit stops for their drivers. (Photograph by David McGee.)

Noted Crew Chief Tim Brewer checks the front brakes on the Maxwell House No. 22 Ford owned by Junior Johnson. Although he never put this car in Bristol's victory lane, Brewer made three trips there with Darrell Waltrip. (Photograph by David McGee.)

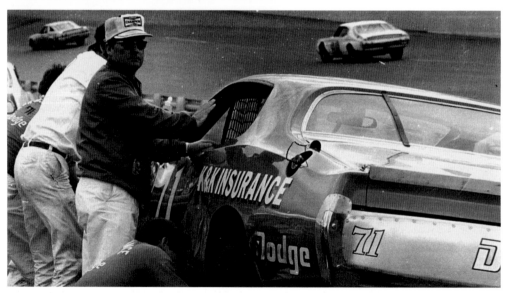

In the Days Before two-way radio communication, crew chief Harry Hyde (center) signals for driver Buddy Baker to wait until crew members finish working on the K&K Insurance Dodge. After qualifying third in the 1973 Southeastern 500, Baker was involved in a hard crash on lap 225 that ended the team's day. (Photograph by John Beach.)

CREW CHIEF MIKE BEAM (left) and team manager Dale Inman survey the damage to the No. 43 Pontiac. Driver Richard Petty crashed prior to qualifying for his final Bristol start in the 1992 August night race. The team made repairs, and Petty scored a 16th-place finish. That night's race also marked the first on the concrete surface and Darrell Waltrip's final BMS win. (Photograph by David McGee.)

MORE THAN JUST THOSE who go over pit wall to service the car, every race team member has specific responsibilities. Here a tire specialist carefully checks air pressure and measures the circumference of each tire to match sets accordingly. Cup series teams frequently change all four tires during every pit stop and use minor differences in tire size and air pressure to adjust the car's handling. (Photograph by David McGee.)

BETWEEN 1985 AND 2005, Richard Childress earned eight Bristol wins as a car owner. In this 1992 photograph, Childress checks his team's progress and driver Dale Earnhardt against the stopwatch. Earnhardt accounted for seven of those wins, including sweeps during the 1985 and 1987 seasons. Kevin Harvick ended a five-year drought, earning Childress a victory in the 2005 Food City 500. (Photograph by David McGee.)

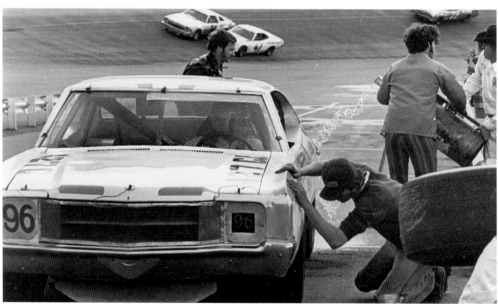

LONG BEFORE HE CAPTURED SIX NASCAR Winston Cup championships as car owner for the late Dale Earnhardt, Richard Childress drove this No. 96 1972 Chevelle. Here his all-volunteer crew services the independent entry. Between 1972 and 1981, Childress started 19 races at Bristol and registered 7 top-10 finishes. (Photograph by John Beach.)

CAR OWNERS AND CREWS

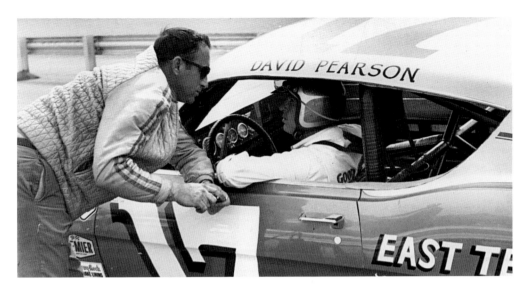

CREW CHIEF DICK HUTCHERSON (left) confers with David Pearson, driver of the No. 17 Holman-Moody Ford, during practice for the 1968 Southeastern 500. They became only the second team to win both Bristol races in the same year en route to winning the 1968 NASCAR season championship. Pearson scored 16 wins during 49 races to nab his second series title. (Photograph by John Beach.)

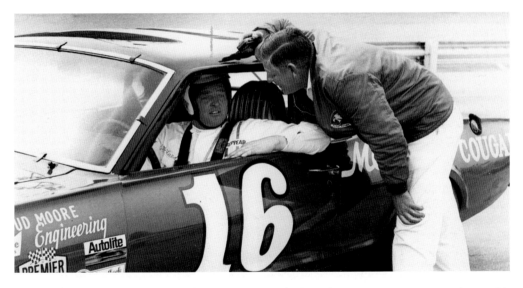

CAR OWNER BUD MOORE (right) listens as driver Tiny Lund talks during a tire test at Bristol. Lund performed double duty that day, handling both this 1968 NASCAR Grand American Series Mercury Cougar and Moore's then–Grand National Ford. Moore earned his only Bristol win as a car owner in the track's second race, the 1961 Southeastern 500. Lund, who was killed in 1975 at Talladega, made nine winless Bristol starts. (Photograph by John Beach.)

CAR OWNER JACK ROUSH (left) shares a laugh with driver Mark Martin prior to qualifying for the 1996 Food City 500. Minutes after the photograph was taken, Martin captured his third straight Bristol pole position. Known as intense competitors, they have posted 2 wins, 20 top-10 finishes, 7 poles, and led 18 different races since 1988. (Photograph by David McGee.)

BRISTOL NATIVE CHRIS CARRIER has earned two wins at his hometown track as a crew chief. Carrier, driver Rick Wilson, and car owner Charlie Henderson combined to win the 1989 Budweiser 200 on a Monday afternoon, after rain forced NASCAR to postpone the event from Saturday. Carrier returned to Bristol's victory lane in 1992 with driver Harry Gant and car owner Ed Whitaker. (Photograph by David McGee.)

STOCK CAR RACING LEGENDS Curtis Turner and Ralph Moody prepare to board an airplane. As car owners, Moody and partner John Holman made nine trips to Bristol's victory lane. Turner, a racing star in the 1960s, qualified on the pole for the 1966 Volunteer 500. He led the first 80 laps of his only Bristol start, but engine problems ended his day. (Courtesy of BMS archives.)

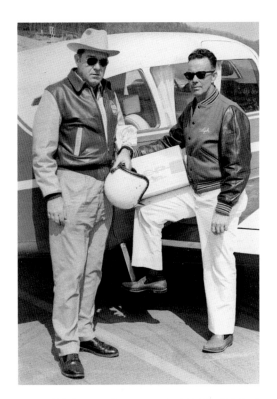

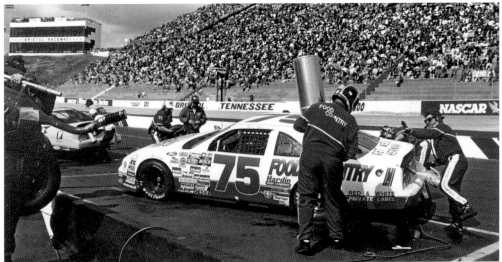

RICK WILSON PITS THE Food Country USA Ford during the 1995 Goody's 250 Busch Series race. Wilson was unable to repeat the magic of the 1989 spring race, when he drove the team to victory lane. The team is based about 20 miles from the speedway in Abingdon, Virginia, and owned by businessman Charlie Henderson. On that day, Wilson qualified 10th but posted a disappointing 27th. Teammate Brad Teague, however, qualified sixth, ran among the leaders all day, and finished a solid seventh. (Photograph by David McGee.)

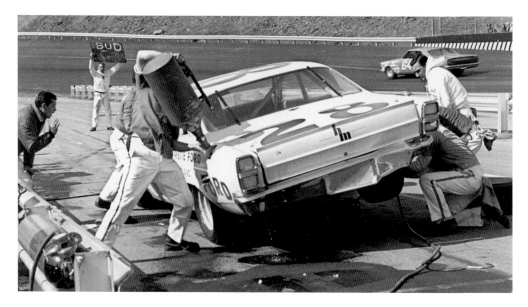

THE HOLMAN-MOODY TEAM adds fuel and right-side tires to Fred Lorenzen's Ford during the 1966 Southeastern 500. Despite qualifying second, Lorenzen led just one lap and dropped out with a blown engine. Only 7 of 32 starters finished that race, the fewest in Bristol history. (Courtesy of the Carl Moore collection.)

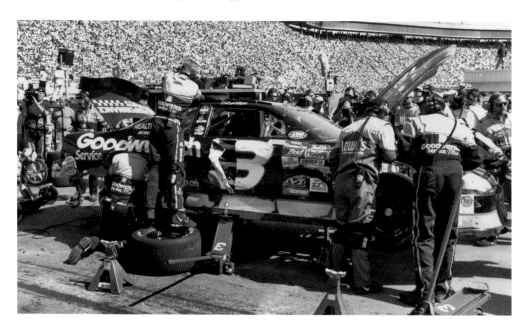

CREW MEMBERS FOR BOTH Dale Earnhardt and teammate Mike Skinner attend to Earnhardt's battered Chevrolet during the 2000 Food City 500. After an early six-car crash prompted extensive repairs, Earnhardt was able to return to the race. He was running at the end but finished a disappointing 39th. (Photograph by Chris Haverly.)

BEYOND THE CUP

We ran a little bit of everything. We ran the Modifieds for a few years, the Late Model Sportsman, that was always a separate race. We ran the Grand American cars, they all ran here at one time or another. One time we had a big country music concert with every big name from Nashville. We sat there waiting for the crowd to show up, but nobody came.

—Carl Moore

WHEN NASCAR BANNED CHRYSLER'S Hemi engine in 1965, the factory sent its biggest stars drag racing. Here Richard Petty's 43 Junior Plymouth Barracuda leaves the starting line during the inaugural NHRA (National Hot Rod Association) Spring Nationals at Bristol Dragway. Petty won his class and was a major attraction at the first major NHRA drag racing event east of the Mississippi River. The ban was rescinded the next year, and Petty returned to NASCAR. (Courtesy of BMS archives.)

IN ITS EARLY YEARS, the speedway regularly hosted the popular Modified coupes. The races drew modest crowds but attracted racers from across the Southeast. Most of the cars sported pre–World War II bodies and V-8 engines. (Courtesy of BMS archives.)

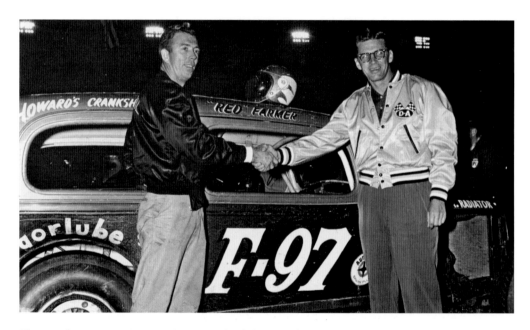

TRACK CO-OWNER LARRY CARRIER (right) congratulates legendary Alabama driver Red Farmer on winning a Modified race at Bristol during the early 1960s. Long before night racing came to television, the track hosted regular weekly racing that attracted many of the Southeast's top drivers. Farmer, a member of the "Alabama Gang," won short-track races over a five-decade period. (Courtesy of BMS archives.)

BEYOND THE CUP

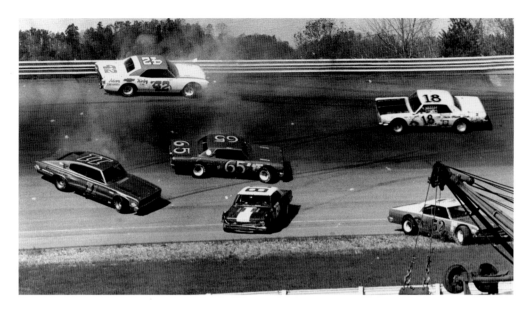

CARS SPIN IN DIFFERENT DIRECTIONS after a multi-car crash during a Late Model Sportsman race at Bristol. The Sportsman class, the forerunner of today's Busch Series, contested several events at Bristol during the 1960s and 1970s. (Courtesy of BMS archives.)

BEFORE COUNTRY MUSIC SINGER Marty Robbins competed in 35 NASCAR Winston Cup Series races, he raced this Sportsman Dodge at Bristol. Robbins, who once featured one of his Dodge Charger race cars on an album cover, never competed in a Winston Cup Series race at Bristol. (Photograph by John Beach.)

L. D. OTTINGER PROUDLY SHOWS off his trophy for winning Bristol's Permatex 300 in July 1973. The NASCAR Late Model Sportsman Series typically ran a stand-alone summer event during the 1970s. Ottinger, a Newport, Tennessee, native, won two with virtually no Winston Cup Series drivers competing. It was a far cry from modern-day racing where Winston Cup regulars, known as "Buschwhackers," often race in both divisions during weekends when both series compete at the same track. (Photograph by John Beach.)

L. D. OTTINGER (2) CAPTURED BOTH the pole and the race win in the 1973 Permatex 300 Late Model Sportsman Series race at Bristol. Here Ottinger leads the Ford (partially obscured) of outside pole-sitter John A. Utsman to the green flag. Note how close the track's original flagstand placed the flagman to the race track and the obvious lack of attendance at the stand-alone event. (Photograph by John Beach.)

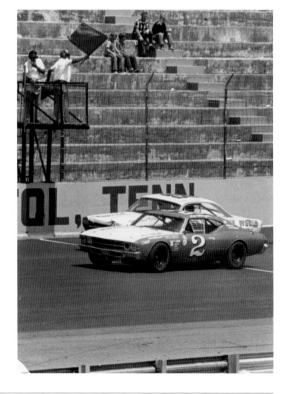

BEYOND THE CUP

DRIVER "IRON MAN" JACK INGRAM (left) accepts congratulations from speedway co-owner Lanny Hester after winning a June 1978 Late Model Sportsman race at Bristol. The Sportsman class was the forerunner of today's Busch Series. Ingram finished fifth in that season's standings but won three Sportsman national titles and two Busch Series championships in his distinguished career. (Courtesy of BMS archives.)

IN SOME OF THE MOST UNUSUAL events ever run at Bristol, diesel-powered big rigs competed in the Great American Truck race, run during April 1981 and September 1982. (Photograph by Mark Marquette.)

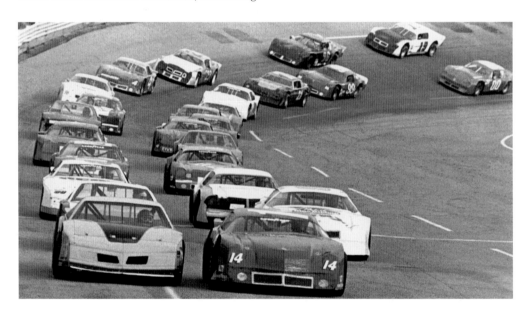

THE CARS AND STARS of the American Speed Association hit Bristol's high banks in May 1983 for the Volunteer 300. Mike Eddy, a seven-time ASA champion, won the race. The ASA made a second trip to Bristol late in that decade, with short-track legend and eventual NASCAR standout Dick Trickle earning the win. (Courtesy of BMS archives.).

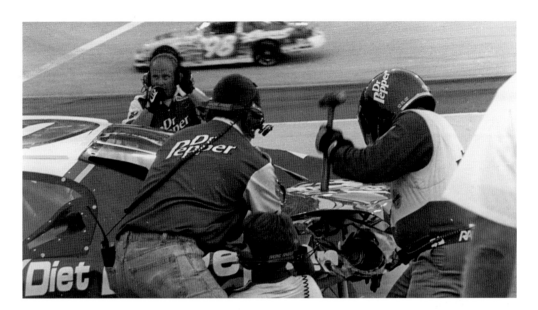

CREW MEMBERS FOR MARK GREEN bring out the hammer to try and repair damage to the Diet Dr. Pepper Chevrolet during the 1999 Food City 250. Green was one of 12 cars involved in a backstretch accident on lap three. Green wound up a disappointed 42nd. (Photograph by Carol Hill.)

WHILE THERE ARE SOME technical differences, NASCAR Busch Series cars have evolved to closely resemble the more powerful Cup series entries. Here 1994 Busch Series champion David Green (44) races side by side with Chad Little (23). Both drivers spent years competing in both divisions. (Photograph by David McGee.)

HARRY GANT (7) LEADS Mark Martin (60) through Turns 3 and 4 during the 1994 Goody's 250 Busch Series race. Martin passed Gant and appeared headed for the win when the caution flag flew, but Martin pulled off the track before the checkered flag was displayed, giving the win to David Green. Martin captured Bristol Busch Series wins in 1989 and 1996, while Gant won a rain-delayed event in 1992. Gant helped make car owner Ed Whitaker, a Bristol native, one of the most successful in series history, as they combined for 20 of Whitaker's 27 victories. (Photograph by David McGee.)

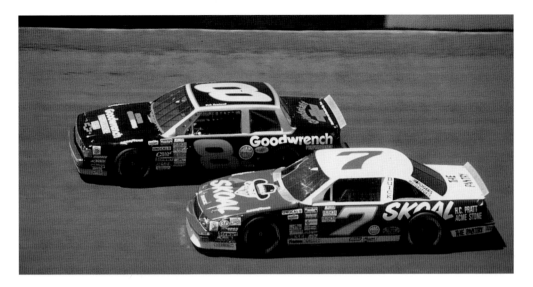

DALE EARNHARDT (8) DUELS with Harry Gant (7) during the 1988 Budweiser 200 NASCAR Busch Series race. Earnhardt went on to post his lone Bristol Busch Series win later that afternoon. Gant, driving Ed Whitaker's Skoal Buick, failed to finish in the top five. (Photograph by David McGee.)

AT BRISTOL, EVEN THE GROUNDS crew is famous. Head painter George Wilson, shown here touching up the railing during the 1990s, became a media celebrity when he was featured in a series of television and radio commercials. He deadpans during the spots about drivers wrecking and "messing up" his concrete walls. He may also be the only painter to be the subject of a bobblehead doll. (Photograph by David McGee.)

OVER THE YEARS, BRISTOL has hosted nearly every kind of motorized competition imaginable. In 1985, the infield was used for a truck and tractor pull that also included this car-crushing Ford monster truck. (Photograph by Earl Neikirk.)

RICK CARELLI RELAXES ON pit road during the first practice session for the NASCAR Craftsman Truck Series at Bristol. Bristol was one of 16 tracks to host the trucks during their inaugural season as a national touring series in 1995. The trucks were part of a summer tripleheader with the former NASCAR Goody's Dash and All-Pro Series. Carelli drove Marshall Chesrown's Chevrolet to victory lane the following season, winning the 1996 Coca-Cola 200. (Photograph by David McGee.)

BEYOND THE CUP

RON HORNADAY JR. (16) RACES with Butch Miller (98) during the 1996 Coca-Cola 200 Craftsman Truck Series race. Hornaday finished eighth during that outing but dominated the following two years, winning both the pole and race in 1997 and 1998 in a truck owned by Dale Earnhardt. The California native won the 1996 series title and came back to win it again in 1998. (Photograph by David McGee.)

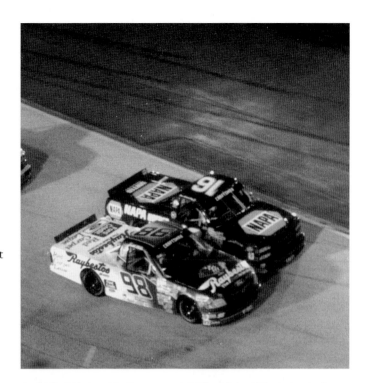

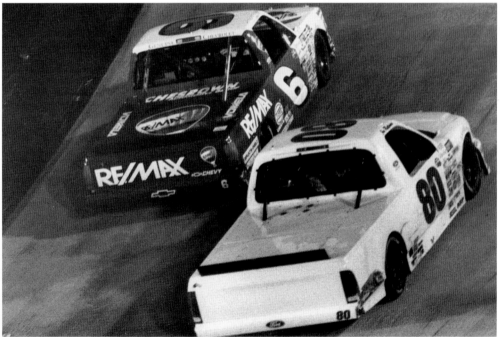

RICK CARELLI (6) PASSES Joe Ruttman (80) during the 1996 Coca-Cola 200 NASCAR Craftsman Truck Series race. Carelli won that race, while Ruttman drove a Jack Roush–owned Ford to the inaugural race win in 1995. (Photograph by David McGee.)

POLE WINNER MIKE COPE struggles to regain control of his NASCAR All-Pro Series Oldsmobile as he heads toward the inside retaining wall. Cope was involved in a multi-car crash during the 1994 Pizza Plus 250 that sheared the fiberglass body on the right side of the race car and caused a small fire. (Photograph by David McGee.)

THE BRISTOL SPEEDWAY GENERATES much enthusiasm and loyalty—more than 200 couples have said "I do" on the start/finish line. The first such ceremony is believed to be this one on June 19, 1993, which featured the entire wedding party arriving on Harley-Davidson motorcycles. During recent years, wedding vows have become part of the August race weekend. (Photograph by David McGee.)

BEYOND THE CUP

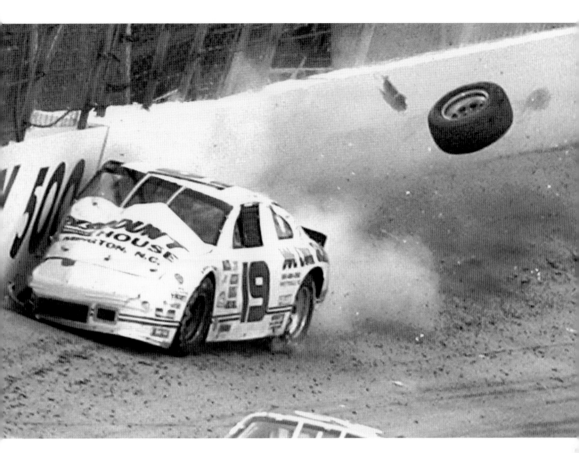

Drivers in the Former NASCAR Goody's Dash Series competed 21 times at Bristol between 1975 and 2003. During that entire time, Joey Miller (19) suffered one of the hardest crashes in series history, slamming into the Turn 2 wall at full speed and sheering the front tire and suspension components off the car. Miller's best Bristol outing came in 1999, when he posted a third-place finish. (Courtesy of *Bristol Herald Courier;* photograph by David Crigger.)

THE LEGENDARY CONCRETE WALLS of Bristol Motor Speedway had the distinctive stain of red clay in 2000 and 2001, as the track hosted summer dirt series races for late-model stock and sprint cars. (Photograph by David McGee.)

WITH THE TRACK'S TRADITIONAL 36-degree banking reduced to 22 degrees by more than 1,000 dump-truckloads of red clay, the World of Outlaws winged sprint cars were able to race three and four wide at Bristol Motor Speedway. (Photograph by David McGee.)

TENNESSEE RACER SAMMY SWINDELL captured the win in his sponsor's race, winning the Channellock Challenge during BMS Dirt Weeks 2001. (Photograph by David McGee.)

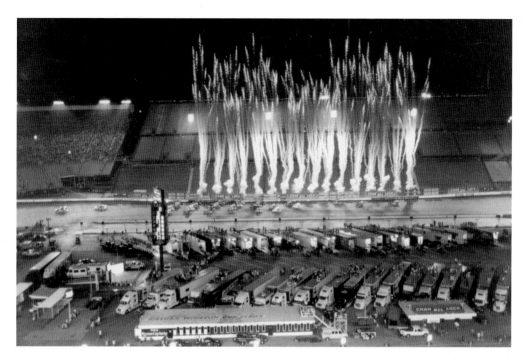

A Tradition during Bristol's dirt weeks was this sparkling fireworks display during the pace lap prior to each feature race. In June 2000, the World of Outlaws sprint cars bunch up along the backstretch prior to starting the 30-lap A-main, which is the feature race of that series. (Photograph by David McGee.)

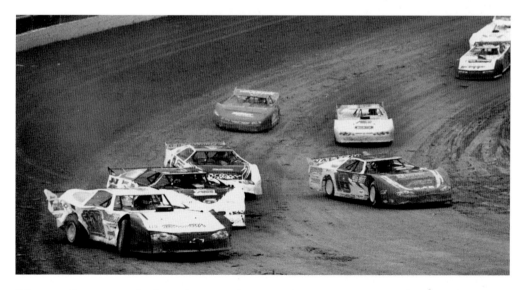

With the Banking of Its legendary turns less severe due to tons of clay, late-model drivers often were able to race four wide during dirt weeks action in 2000 and 2001. (Photograph by David McGee.)

RADIO PERSONALITY "JOHN BOY" ISLEY waves people out of his way while driving Food City's giant shopping cart during pre-race activities at Bristol in August 1997. What was supposed to be a low-speed parade lap turned into a "world record" pass for Isley in the Chevrolet-powered promotional vehicle. That speed prompted network broadcast partner Billy James to hold on for dear life. (Photograph by David McGee.)

NOTED MOTORSPORTS ARTIST SAM BASS (seated) signs autographs during the semi-annual Food City Family Race Night. The grocery chain, which also sponsors Bristol races, hosts about 40,000 fans at autograph parties in Kingsport, Sevierville, and downtown Bristol. The events typically attract dozens of drivers and other racing personalities, and proceeds go to local charities. (Photograph by David McGee.)